SEX DESIGN

Edited by Max Rippon

COLLINS|DESIGN

An Imprint of HarperCollins*Publishers*

SEX DESIGN

Copyright © 2006 by COLLINS DESIGN and LOFT Publications

HarperCollins books may be purchased for educational, business, or sales promotional use.
For information, please write: Special Markets Department, HarperCollinsPublishers,
10 East 53rd Street, New York, NY 10022

First Edition published in 2006 by:
Collins Design
An Imprint of HarperCollinsPublishers
10 East 53rd Street
New York, NY 10022
Tel.: (212) 207-7000
Fax: (212) 207-7654
collinsdesign@harpercollins.com
www.harpercollins.com

Distributed throughout the world by:
HarperCollinsPublishers
10 East 53rd Street
New York, NY 10022
Fax: (212) 207-7654

Packaged by
LOFT Publications
Via Laietana 32, 4.º Of. 92
08003 Barcelona, Spain
Tel.: +34 932 688 088
Fax: +34 932 687 073
loft@loftpublications.com
www.loftpublications.com

Editor: Max Rippon
Text: Max Rippon, Lou Andrea Savoir, Bridget Vranckx
Research: Lou Andrea Savoir, Bridget Vranckx
Editorial Coordination: Catherine Collin
Art Director: Mireia Casanovas Soley
Layout: Ignasi Gracia Blanco

Library of Congress Control Number: 2006929065

ISBN-13: 978-0-06-085965-7
ISBN-10: 0-06-085965-2

Printed by: Cayfosa-Quebecor. Spain

First Printing, 2006

→ **INTRODUCTION**

SEX DESIGN

Sex. It is mysterious and universal, political and pleasurable, humorous and titillating, and at times has been considered shocking and reprehensible. However, regardless of our personal feelings about it, sex is something we simply can't ignore.

The suggestion of sex can be found anywhere and everywhere: garden hoses, bicycle seats, fire hydrants, parking cones, trains (especially when entering into tunnels), skyscrapers, and vibrating cell phones; every protrusion and crevice can be construed in a sexual way if you're looking at it in the right way, or if you're just in the right mood. Because sex grabs our attention and speaks to us in a language we can all understand, there has never been a shortage of designers, artists, architects, and creative minds from all walks of life ready and willing to feed its insatiable appetite, spread it to others, try something new, dress it up, dress it down, and approach it in ways that we never considered. The only problem, however, is that more often than not these designs

turn out to be tacky and cheap. We cannot let this tarnish our view of the theme of erotic works as a whole. Sex is a universal topic, which is very relevant and has helped bring our entire civilization to where it is today.

We are living in a time that enjoys more sexual freedom and open-mindedness than ever before. This is thanks both to previous generations who challenged antiquated beliefs and taboos as well as to our current forms of mass media that allow nearly anybody access to information from across the world. The sexual revolution has entered a new stage; it has been digitized, globalized, and sped up to a rate that was never before possible. The artists and designers in this book reflect contemporary attitudes, styles, mentalities, and technologies, but have not forgotten about the past. Their objects and artworks that inspire, shine, and breathe new life into one of the oldest subjects imaginable. They are also the individuals who are continuing to dig deeper, give in to that the primal force, and push things forward for the new generations.

This exploration takes you through sex's fun side, dark side, kinky side, and maybe even a few sides you didn't know existed. Some of these artists and designers are on a mission to spread knowledge and a message, while others, well, they just want to have a little fun along the way. This collection of talent will whet the appetites of everyone in need of a fresh outlook on one our favorite, and most ancient, topics. These creative and original ideas will spice up our imaginations and stimulate us to take a new look at our surroundings, our taboos, and ourselves.

10

→ **WEARING IT**

Fashion, clothing, and style are all about decorating our bodies and showing people who we are. By covering up our skin, even slightly, we spark the imagination of others and turn the body into something mysterious and certainly something to be desired. The way we dress ourselves is our plumage—our way of adorning ourselves, standing out, and tempting those around us.

Styles and fashion trends have grown out of cultural traditions, art, music, sports, pop culture, and underground culture—not to mention basic functionality—and can be a way for people to identify with a group, as well as make their own statement. Fashion has power and can change how we think: fashion icons from Audrey Hepburn and Jackie Onassis to Bettie Page and Vivienne Westwood have helped shape generations' identities and sexuality.

The power that clothing can have over culture, mentalities, taboos, and reinventing all of the above has also brought many political artists into the fashion ring with some moving and global results. The artists and designers in this chapter have taken their art to new places while continuing to base it on our most basic and common element, our own bodies.

A guy walks into a bar and hands the bartender an oversize-looking wallet with the words "Vinnie's Tampon Case" printed on it in big bold letters. The bartender's eyes light up and he thinks this tampon case is the coolest thing he's ever seen. He stuffs it in his back pocket and then says, "You think I could get one for my girlfriend too?" This might sound like a joke, although not a very funny one, but since **Vinnie Angel** began making his signature **Vinnie's Tampon Cases** he's handed out thousands of free tampon cases to women and men, all of whom are more than pleased to receive a free, stylin', and useful gift such as these cases. Women want them for storing tampons and other items, while men either snag them for their girl-friends or keep them for themselves as wallets, glasses cases, whatever. While the look of these unique fashion accessories is very lighthearted, the results are unprecedented. Men actually *want* to talk about menstruation and women have no problem proudly mentioning their periods. Who would have thought that a little canvas case could change the way men and women discuss a topic that has long been one of the most awkward divides between the genders? It's all in the design.

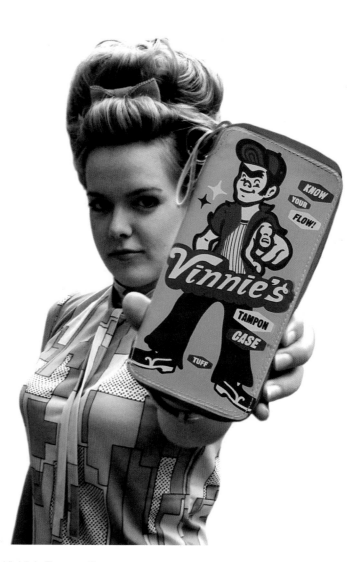

Vinnie Angel. Vinnie's Tampon Cases

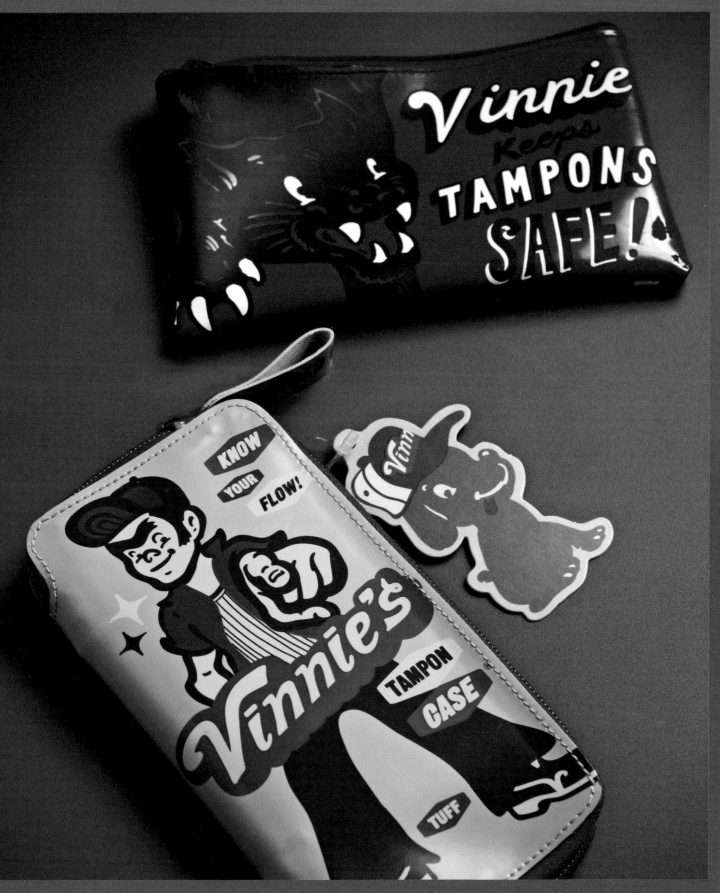

Vinnie Angel, Vinnie's Tampon Cases

Long-distance relationships can be incredibly hard to sustain. No matter how often we try to stay in contact via telephone, e-mail, instant messenger, video messaging, etc., there's just no substitute for physical contact. So what could be better than being able to actually transmit a hug to somebody? This is what inspired **Ryan Genz** and **Francesca Rosella**, founders of the innovative design firm **Cute Circuit**, to create the **Hug Shirt**. This wearable telecommunications device uses Bluetooth and our cell phones to send each other all of the sensations of a warm loving hug just as if you were sending a text message. The sensors in the shirt can send and receive the strength of the touch, the warmth of the body, and even how fast the heart is beating, so even from thousands of miles away you can physically show somebody just how excited they make you. Now such intimate and private communications via our clothing can be shared, imagine what might be possible if Cute Circuit started designing underwear.

Ryan Genz and Francesca Rosella. Hug Shirt for Cute Circuit

Ryan Genz and Francesca Rosella. Hug Shirt for Cute Circuit

The pinup girl is classic Americana. Alberto Vargas and Gil Elvgren, two of the most well-known artists in this genre helped shape America's image of the ideal woman, as well as paved the way for all modern adult magazines. Pinup posters and photographs became staples in nearly every soldier's bunker from the beginning of the 20th century on, and so too did these girls start to find their way tattooed into the skin of sailors, soldiers, and eventually men and women from all walks of life. Classic tattoo flash grew up alongside the pinup movement and the two have become inseparable. One of today's most talented tattoo artists continuing this tradition has to be **Joe Capobianco**. His style is distinctly cute as well as sexy, and attracts those with a taste for incredible tattoos and a touch of eroticism. Much like the classic masters, he focuses more on the little details that characterize his girls, rather than on simply gratuitous sex appeal. The pinup girl represents a period in American history, but whether she is permanently inked into our skin or not, she will always remain a part of our culture.

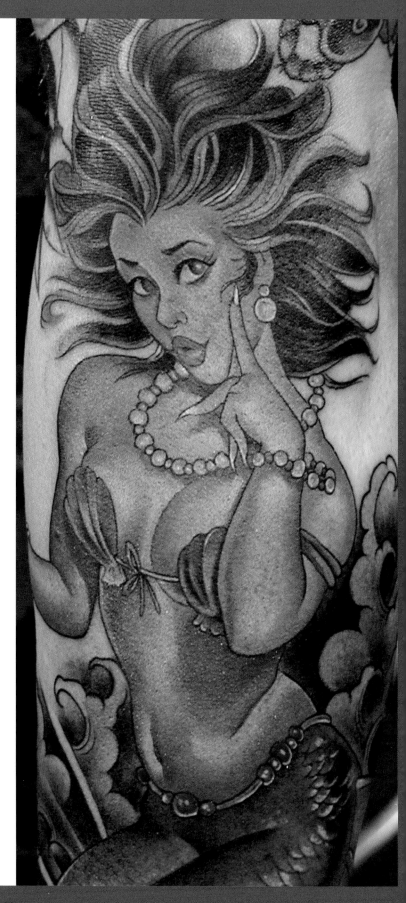

Joe Capobianco. Mermaid Tattoo

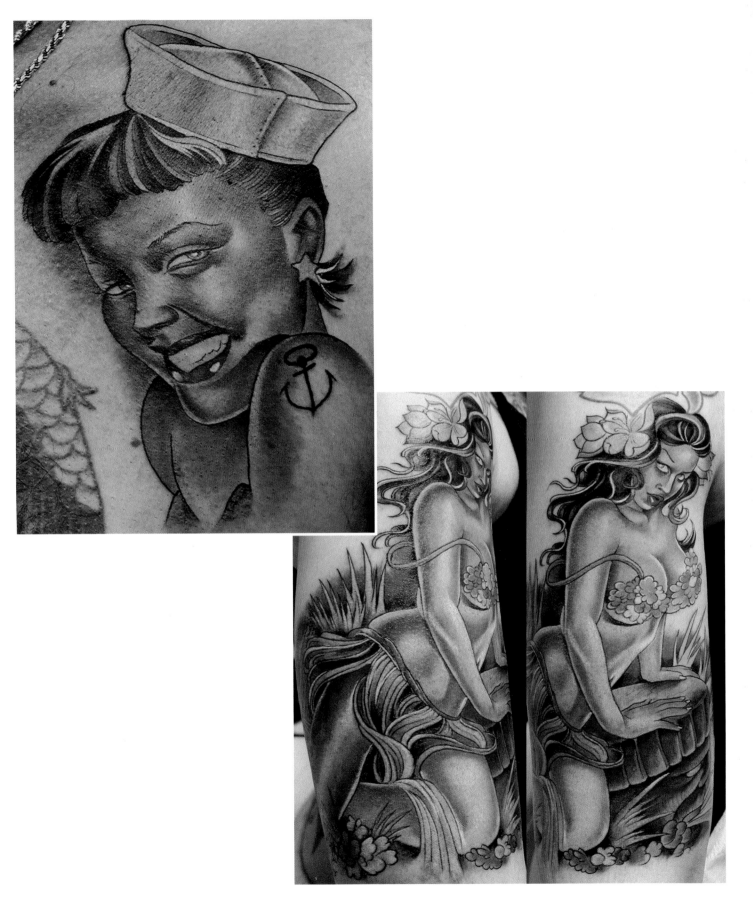

Joe Capobianco. Sailor and Hula Girl Tattoos

From the velvety crevices penetrating the sides of glaciers to the enormous volcanoes spewing forth their fire, Mother Nature is not shy about her sexual innuendos. The organic and sexual are ever-present elements in this world and have always been two of the biggest influences for artists throughout history. Here they have served as the inspiration for this intimate collection of jewelry by the artist and designer **Nicolas Estrada**. Whereas most jewelry acts as simple decoration, these pieces are a reflection of the sexuality of the world around us and highlight this eroticism in their shapes, as well as in how they adorn our bodies. There are many things in this world that can be seen as insinuating something erotic and often that's exactly what they're meant to do.

Nicolas Estrada. Fidelity

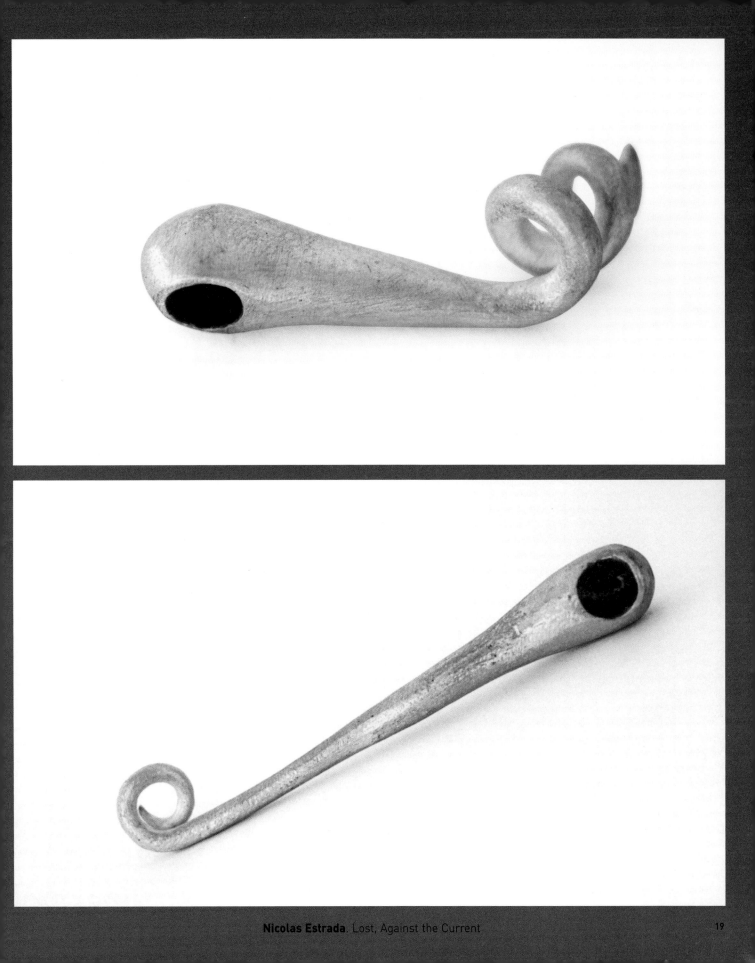

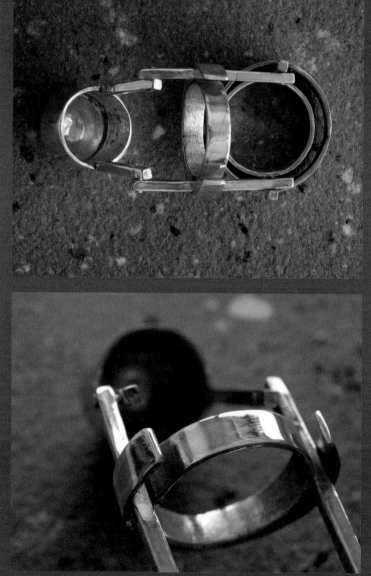

C'mon, you do it. You know you do it. We all do it. We love to do it. But even in today's world women are much more hesitant than men to talk about masturbation. When the artist and jewelry designer **Montse Palacios** created her erotic line of jewelry, she wanted to focus specifically on female sexuality. The designs, as well as the fine silver work, appeal to aesthetic tastes in an elegant way; however, these pieces also have an additional purpose for the wearer. Without being too suggestive, these wearable works of art incorporate sensually smooth finishes and carefully rounded components to allow them to be very stimulating in more ways than one. With the proper fashion accessories, we may be able to flaunt our "secret" activities in a very beautiful and discreet way.

Montse Palacios, Clitoris Ring

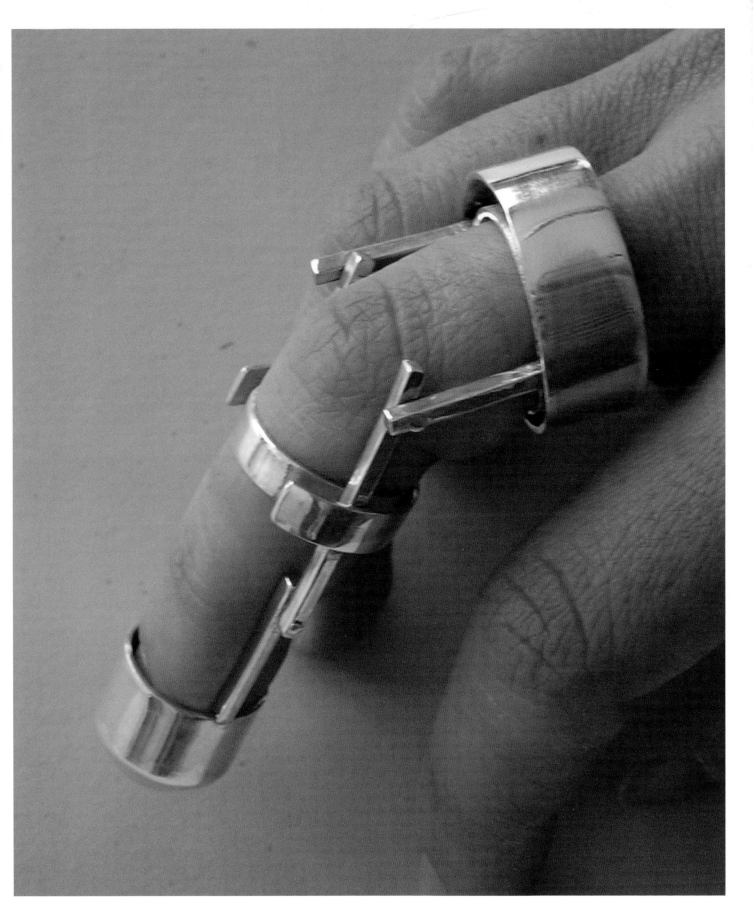

Montse Palacios. Clitoris Ring

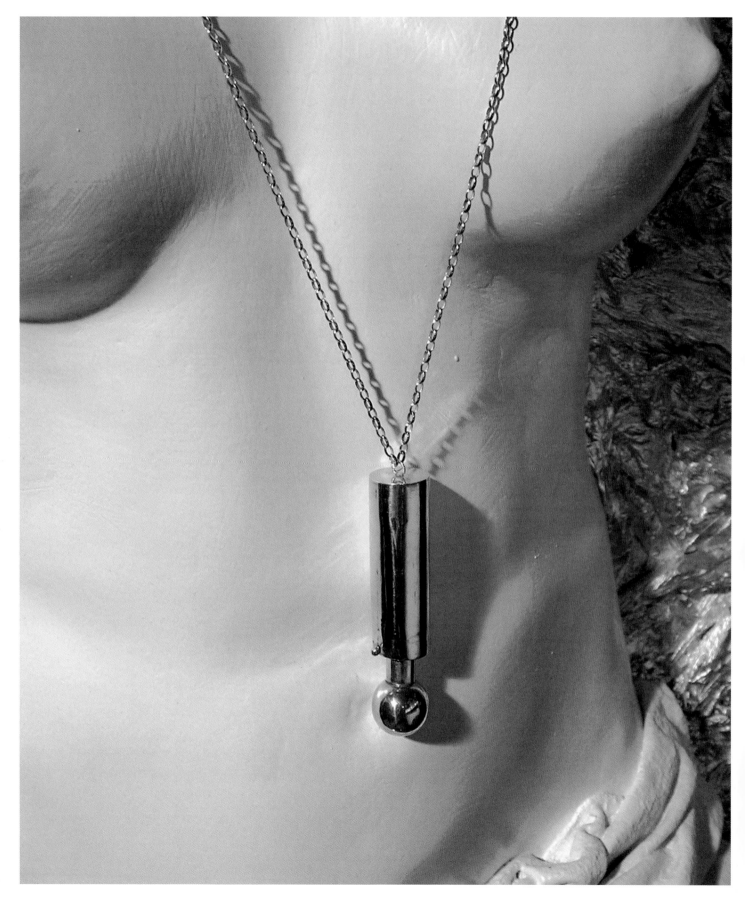

Montse Palacios. Necklace

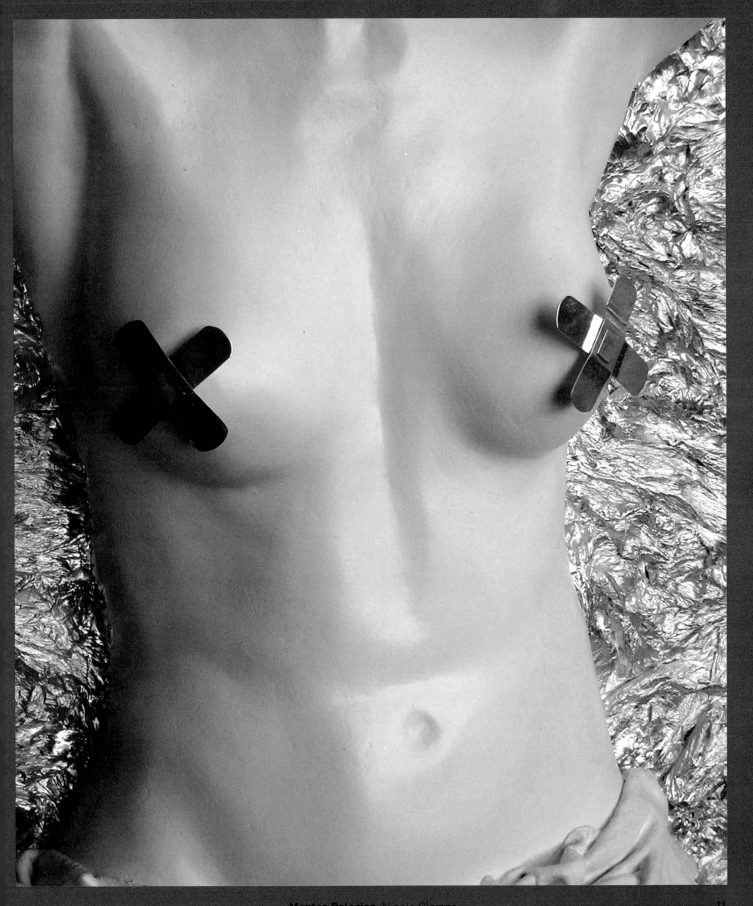

There have been campaigns across the world trying to make condoms fashionable, but never have the lifesaving prophylactics actually been turned *into* fashion. After working for years in Brazil's fashion industry **Adriana Bertini** had learned a lot about designing clothing, as well as the sort of power that fashion and art can have over the public. Soon after starting to work at an AIDS prevention group she began creating her own elaborate gowns, costumes, suits, and paintings, using only thousands of camisinhas ("condoms" in Portuguese). They are intended as a way of opening up discussions about health, prevention, fashion, behavior, aesthetics, politics, education, and environment. They are art objects that make dialogue easier, dialogues that may be considered taboo in certain parts of the world. Her work has been exhibited in 15 countries in four continents, with more to come, and she has spoken at various conferences for the United Nations, thus spreading her message as globally as possible. Her creations are only meant for special occasions, and in that way they also reflect the use of condoms themselves: if they are used at the right time they can make a big difference.

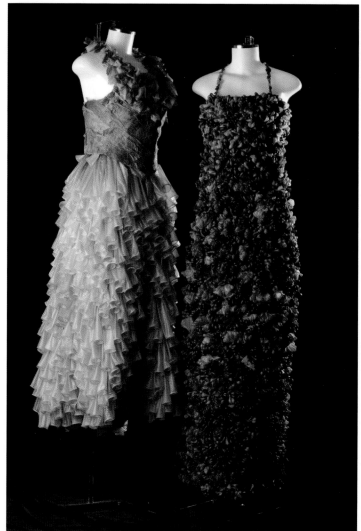

Adriana Bertini. Condom Gowns

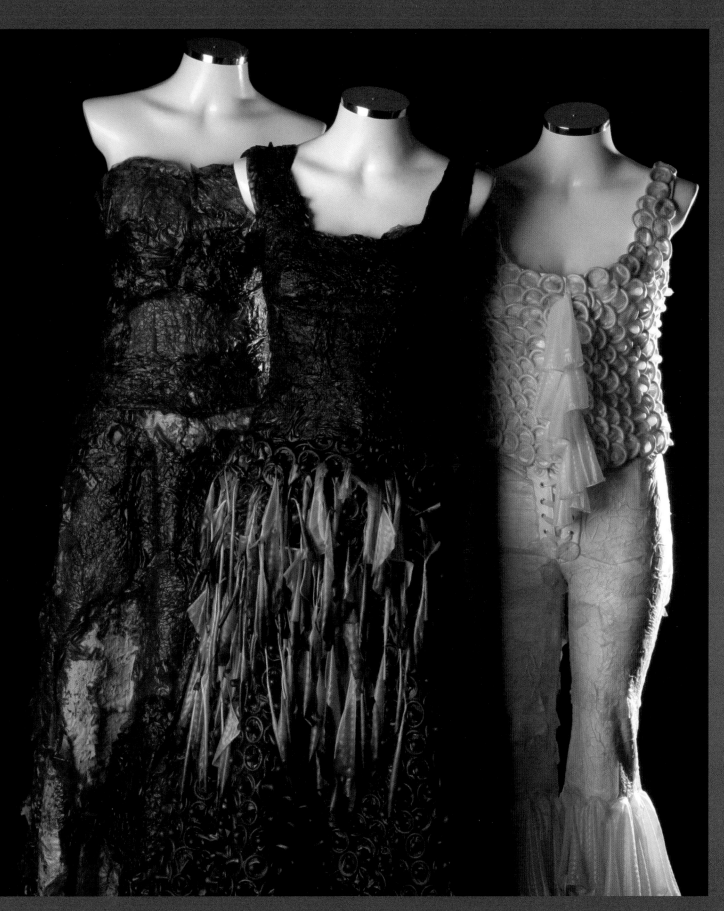

Adriana Bertini. Condom Gowns

Vanessa Fristedt, designer and founder of **Swedish Blonde Design**, knows that selectively covering up your body excites our imaginations much more than complete nudity. But what about the other way around? What happens if we are covered from head to toe and then pin on a few of Vanessa's **Nipple Badges**? While they leave little to the imagination, they certainly excite a smile, not to mention letting people know that you've never been a big fan of those little stars on the covers of porn magazines.

There are few people in this world who would debate the high heel's status as one of the sexiest pieces of footwear in existence. It has certainly become one of the most fetishized objects ever, and we can be sure that Freud would have had a field day had he seen **Bruce Gray**'s enormous metal sculptures of women's shoes. Since the mid-1990's the artist has been, among other things, creating massively oversized sculptures of high heel shoes. Since his shoe sculptures have received more global press than any of his other work, we can be sure that our own fetish with the high heel is not going anywhere soon.

Bruce Gray. High Heel Metal Sculptures

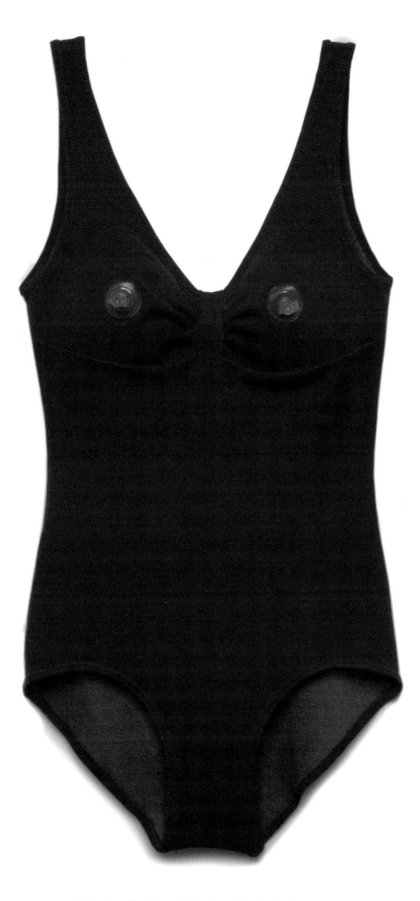

Catherine Gerberon. Vain Sunshine for Intimsport

The key to **Intimsport**'s genius has been converting the mundane and putting a new twist on classic designs. Designer and founder **Catherine Gerberon** has always made work that is at once creative, intimate, and of course, amusing. Whether or not the inflatable bathing suits, sexy dish-washing gloves, or tampon with a scale on it actually functions better than the competition is beside the point; these designs help us laugh at ourselves and show our self-confidence, the sexiest possible attitude.

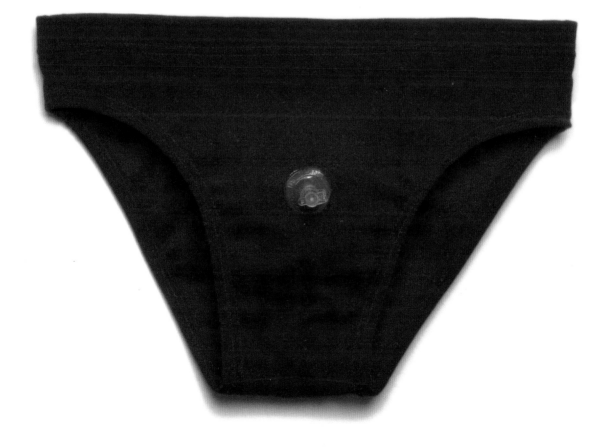

Catherine Gerberon. Vain Sunshine for Intimsport

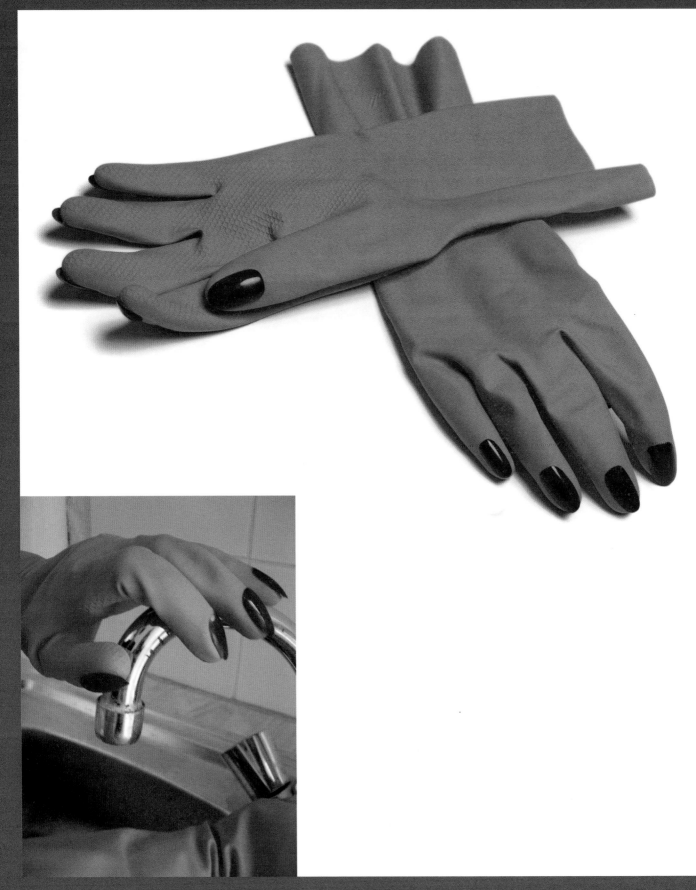

Catherine Gerberon. Bella Martha for Intimsport

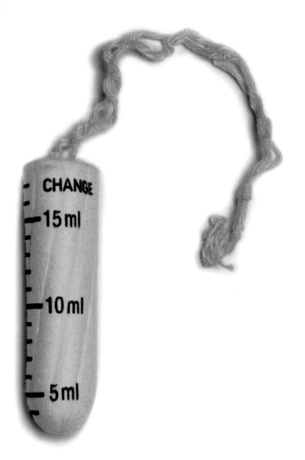

Catherine Gerberon. Tampon With Milliliter scale for Intimsport

There is a lot of message-bearing underwear out there, be it in text or image. However, the result is rarely as pretty and candid as **Mariana Chiesa**'s limited-edition screen-printed designs for **Papabubble**. Most of us won't be able to choose between the mask-wearing and face-revealing options, since we'll relate to both.

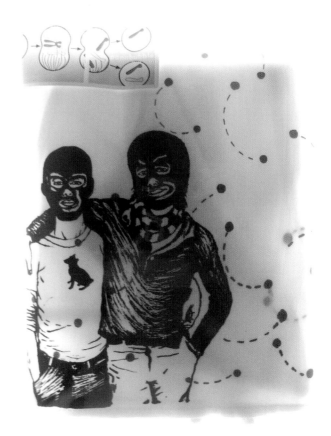

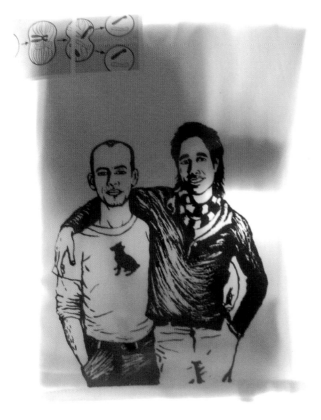

Papabubble and Mariana Chiesa. Lovely Underpants

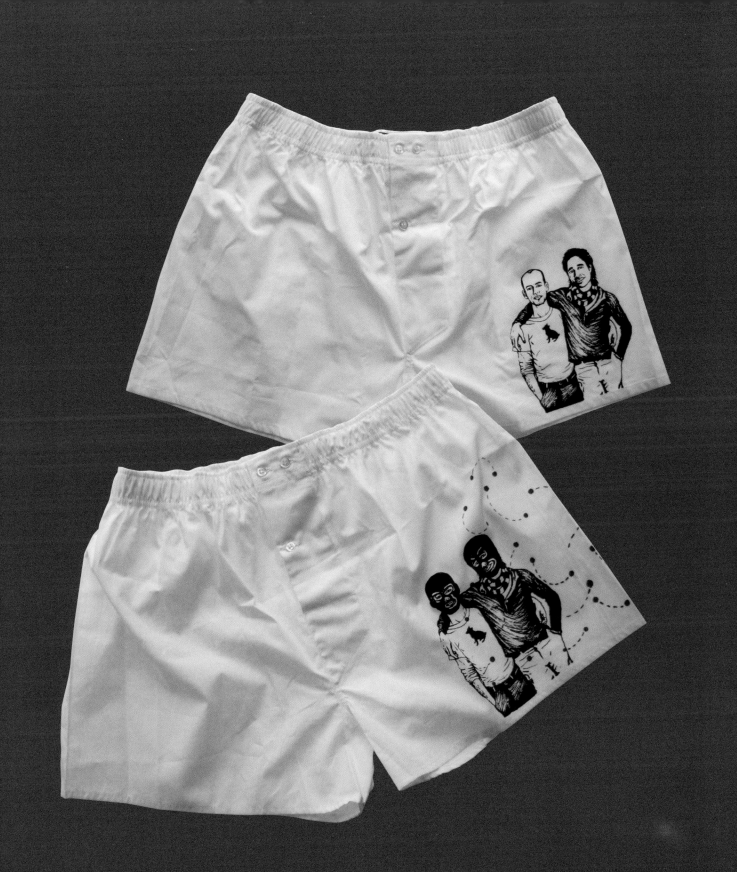

Papabubble and Mariana Chiesa, Lovely Underpants

Sex and clothing have gone together since the fig leaf was in style. The sexiest fashions have always been those that are subtle and unique, but make sure to raise our pulse just a bit. While it may appear slightly abstract at first, **Sascha Quiambao**'s **Eat Me Out** shirt, produced by his company **Smut Clothing**, subtely caresses our interest as it makes love to our sexuality.

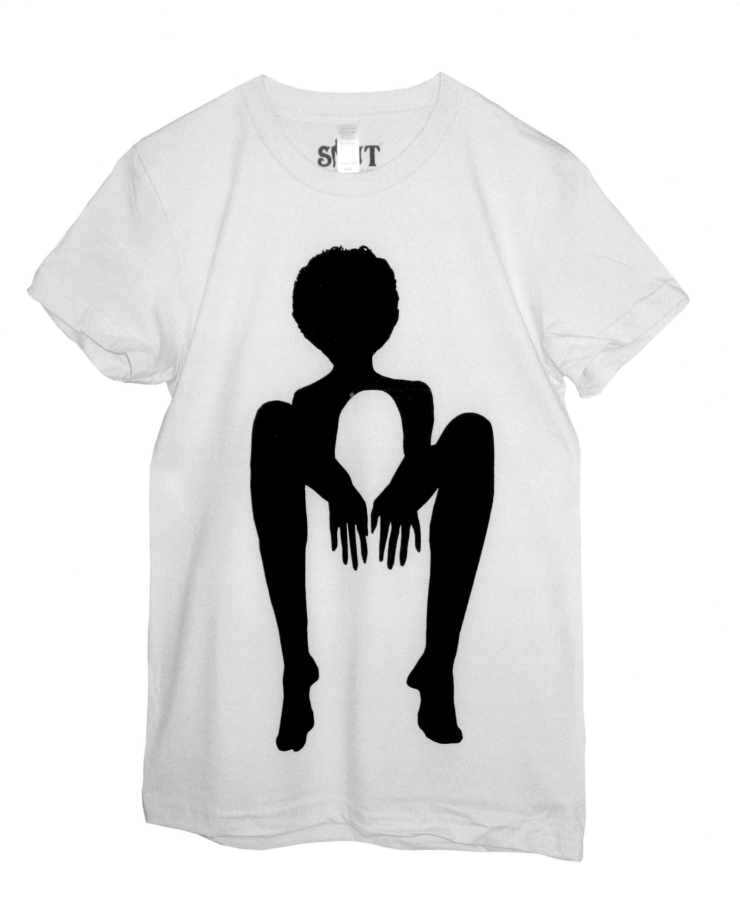

Sascha Quiambao. Eat Me Afro for Smut Clothing

'O Grrls

1. A girl straddling the line between innocence and raw sexuality, playfulness and seduction. May act as an object of desire but is always in control. Tough and tender. When she wants to share with you just how sexy she is she will do so, and you will love it.

2. Wearer and supporter of **La Fille d'O**.

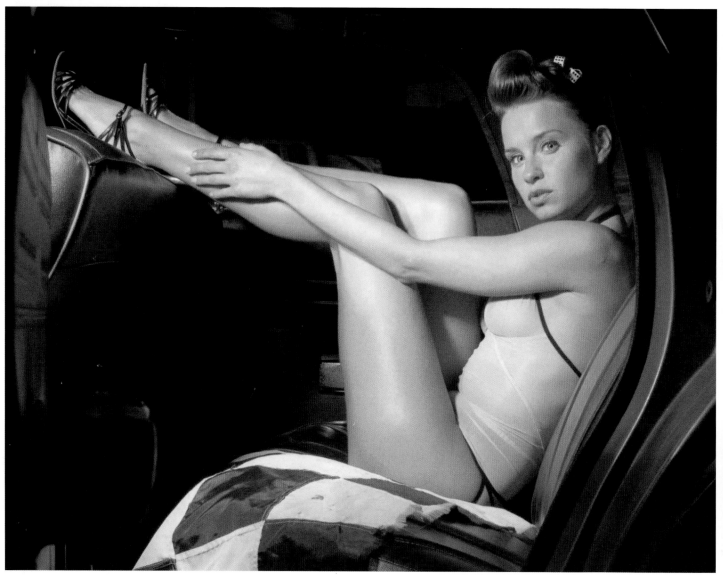

La Fille d'O. Lingerie and Bikini Collection

La Fille d'O is a young lingerie company from Belgium that has built its style upon a foundation of independence and self-confidence. Whereas the traditional approach to lingerie may be decorative, light, and a "way to please your man," La Fille d'O embodies an image that is erotic, badass, and stylish, but still comfortable and sensual. While most ad campaigns for lingerie might include supermodels prancing around on clouds, La Fille d'O creates campaigns like the one for their **'O Grrls Going South** collection. The 'O Grrls pose with classic muscle cars in a way that seduces, but also shows off their own power over the machines, the viewer, and, most important, themselves. But this isn't all just show. La Fille d'O's designs are always meticulous, detailed oriented, and original, and when you combine that with an attitude of female empowerment and style you can't help but get excited, whether you're a guy or a "grrl."

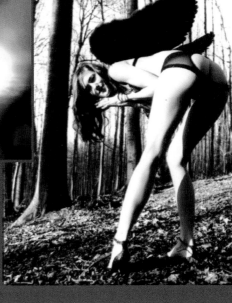

If you want to change the world, start with a T-shirt. This seems to be the sentiment shared by hundreds, if not thousands, of artists working today who are using this democratic medium to communicate everything from a sense of humor to tastes in pop culture, and certainly political beliefs. Beginning with a gallery show in Lisbon in 2004, artist **Miquel García** staged an on-going art project called **AIDS Live AIDS Love** as a way of discussing the interconnected themes of love, sex, and safety. The T-shirts are just one extension of the multifaceted project. The idea of the project is to garner popular support and recognition of this crisis through artwork, products, and performance pieces. It certainly puts it in your face when someone "accidentally" spills a thousand condoms in the middle of a crowded street.

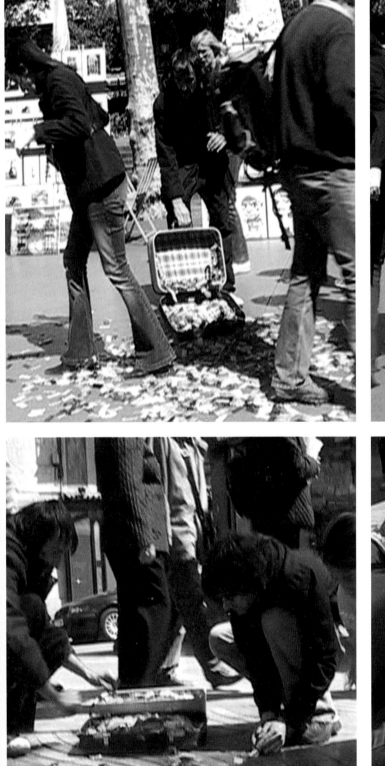
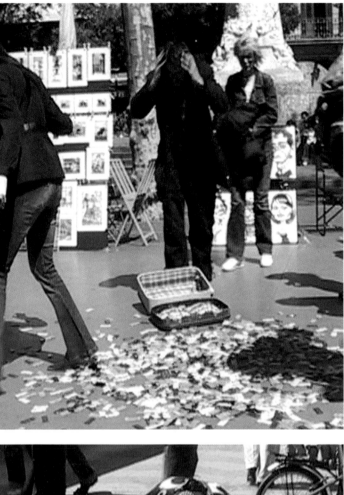
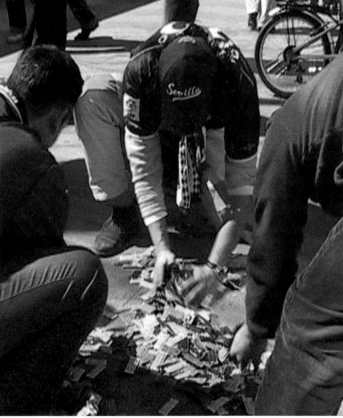

Miquel García. Performance in Barcelona

40

→ HAVING FUN WITH IT

As a culture, we are obsessed with sex and have gone to amazing lengths to create instruments to enhance it, remove its perils, and separate it from its primary reproductive function. From our very first orgasm we can just feel that sex deserves to be a fun and life-enriching activity.

The majority of product development in the sex toy industry (or "adult novelties," as they are usually called) takes place outside the upper tiers of the design world-leading to some interesting and often strange products. In looking at their offerings you can feel the industry groping around in the dark (no pun intended), still trying to add a little something extra to the basic act. When it comes to hedonistic matters, we can truly see how far the human imagination can go .

But it seems that design and sex have truly come together in the present day. Today's design leaders have bent their minds toward sex and produced a dazzling array of accessories and enhancements, from couture indulgences to whimsical trifles. The products featured in this section have various goals and uses, but all celebrate the joy of sex and try to add their own touch to it. In reviewing the contents of this section I find inspiration in each example, but more so in the general state of the world, a world grown open enough to foster the application of creativity to sex. And that alone has the power to open up the positive potential of sex for all of us, thus providing sex with a much-needed injection of fun. Pun intended.

Eric Singley, Curator of the Hollywood Erotic Museum

The very first electric vibrators appeared in the late 19th century and were industrial-sized permanent fixtures in doctors' offices. When a woman came down with a case of "female hysteria," which meant almost any kind of mental or emotional distress, the doctor treated the patient by inducing "hysterical paroxysm," better known today as an orgasm. The treatment was very popular, but before vibrators were available doctors were forced to administer the treatment by hand. Manually masturbating up to 10 or 20 women a day was a long and tiring process, though, so they decided to invent a device that could give them a helping hand and speed things up. It didn't take long for the consumer market to pick up on this, and vibrators were soon advertised as "medical aids" and sold in catalogs such as Sears, Roebuck's. This didn't mean it was now acceptable for women to masturbate, but that the toys' function was hidden under the guise of medicine; this cover was quickly blown when vibrators began appearing in 1920s stag films. Today, vibrators come in all shapes and sizes and are not bashful about their true purpose, but still many of them remain unattractive and devoid of any sense of design. This is what inspired **Myla**, a British chain of erotic boutiques, to begin working with well-known artists and industrial designers outside of the sex industry to create a line of designer sex toys that are just as pleasurable to look at as they are to use. Judging by the success of these products, exemplified by the hundreds of people who had to be placed on waiting lists just to get one, they certainly hit on something: good design can get us hot.

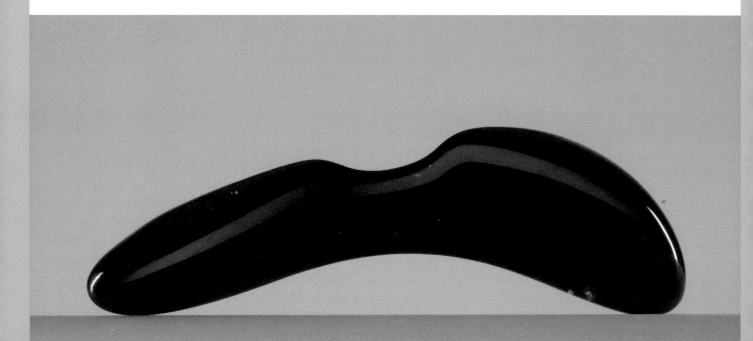

Mari-Ruth Oda. Bone Vibrator for Myla

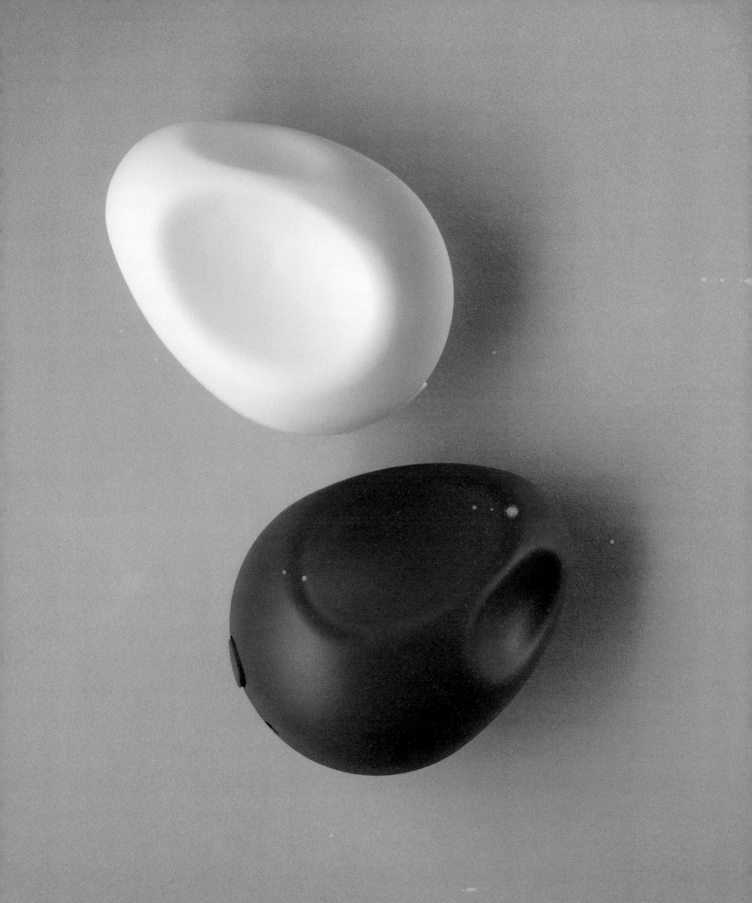

Mari-Ruth Oda. Pebble Vibrator for Myla

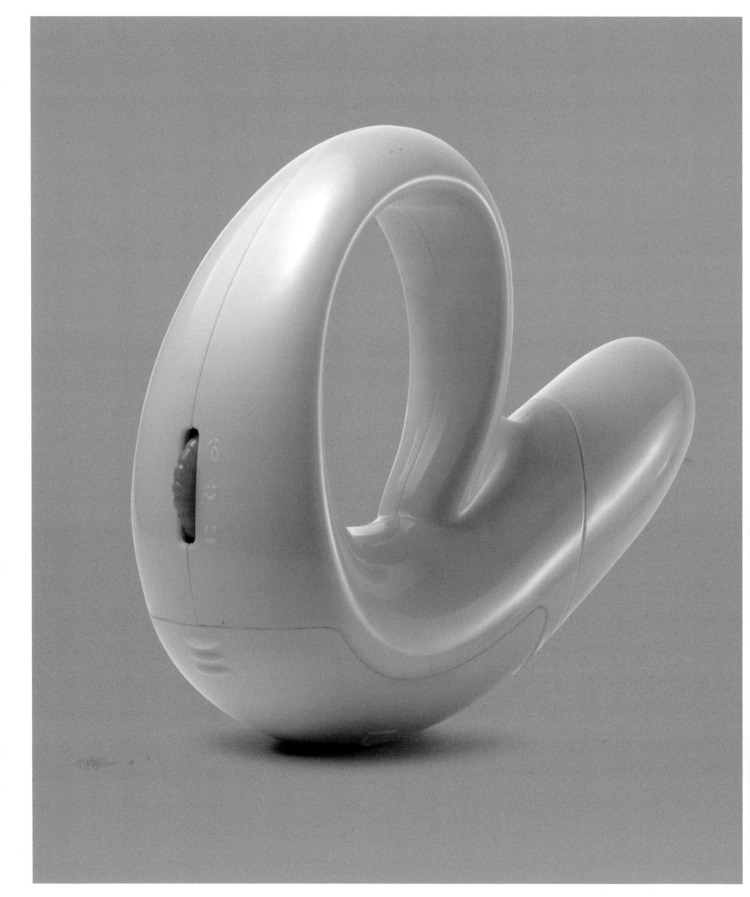

Scott Henderson. C-Shell for Myla

As we all know, sexual freedom and condoms go hand in hand; if you want to enjoy sex, you have to be safe about it. Everyone knows they are necessary but condoms can be awkward little things that we don't really want to have on display. Because of that, they normally find themselves hidden away at the back of a drawer, in a closet, or, as we've all been told isn't a good idea, carried around in a wallet. Perhaps for people who are a little bolder, or who don't have parents stopping in very often, a box is left out on the night table, ready at all times. However, for the majority of us that's just not the "proper" thing to do and some sort of discretion is necessary. When **Dominic Bromley** created the first all-ceramic **Prophopot,** he wanted to provide easy access to these essential bedroom accessories in an attractive and functional way. The shape hints at the contents, but in a way that won't make you embarrassed if your mother drops by unexpectedly. This piece has exhibited in numerous design shows to very positive responses, with the rubber version winning an award at its premier at the 2001 100% Design Show in London.

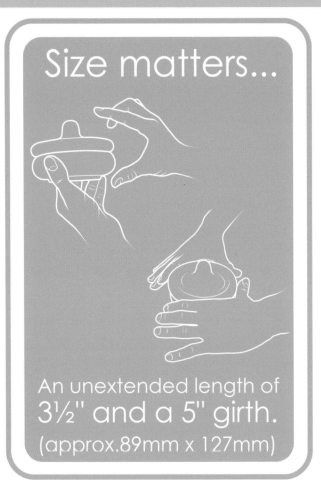

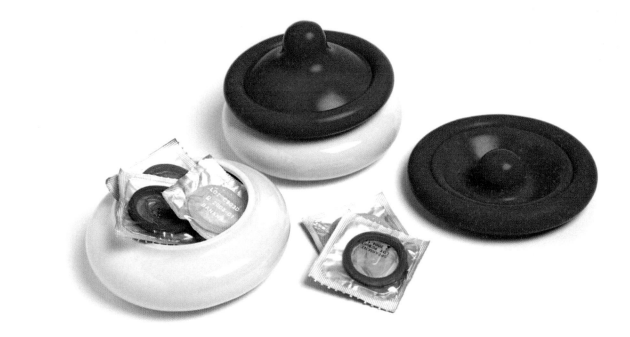

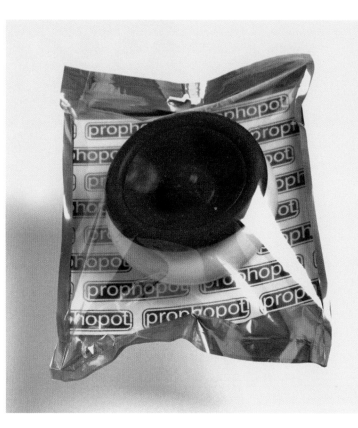

Dominic Bromley. Rubber Prophopot for Scabetti

When we were kids, some of the most fun we ever had was in the bathtub, even if it took some convincing to get us in there in the first place. When **Tony Levine**, the designer and founder of **Big Teaze Toys**, wanted to create vibrating toys that would be bright and innocent, and would make any bath time a lot more fun, he thought back to the classic accessory we all used to love, the rubber duckie. Big Teaze Toys' line of waterproof vibrators is designed to bring a smile to your face before, during, and after the act. Unlike the majority of phallic or explicit sex toys on the market, these designs bring a sense of innocence back to playing with yourself.

Tony Levine. I Rub My Penguin Vibrator for Big Teaze Toys

Tony Levine. Flower Power Vibrator for Big Teaze Toys

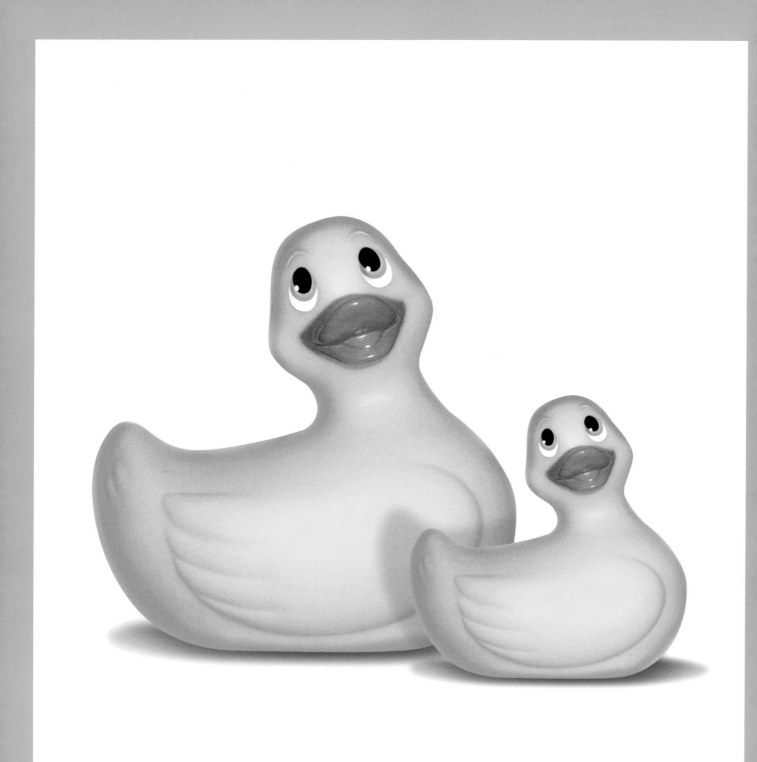

Tony Levine. I Rub My Duckie Vibrator for Big Teaze Toys

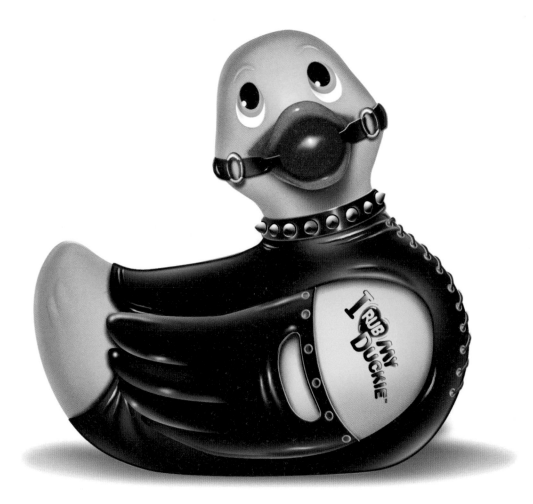

Tony Levine. Bondage Duckie Vibrator for Big Teaze Toys

Since the Jetsons and Flash Gordon, we have always thought of the future as being filled with flying cars, funky high-tech clothing, and ultra-cool undulating architecture and design. Since the beginning of the 1990s, that future has been available to us through the designs of **Karim Rashid**. He became one of the most prolific and important names in the design world today by adapting his work to every imaginable project, including cosmetics, furniture, jewelry, restaurant interiors, clothing, eyewear, kitchenware, watches, lamps, manhole covers, and even an entire hotel (from the architecture down to the tablecloths). His work is often considered sensual, and he has no problem admitting there is often something sexual about it. The **Karim Sutra**, his sexual "landscape" sofa, was a project that remained a mere fantasy until he was finally invited to exhibit in the New York Museum of Sex. He seized the opportunity to bring this piece to life, and what resulted was a piece of sexual furniture so unlike anything else that existed that its erotic functions were nearly unrecognizable; however with ergonomic support for 36 different positions, it possibly does more than any swing, harness, or body pillow out there. Because of the subtlety and artistry in this design everyone can have fun with this piece, whether sex is involved or not.

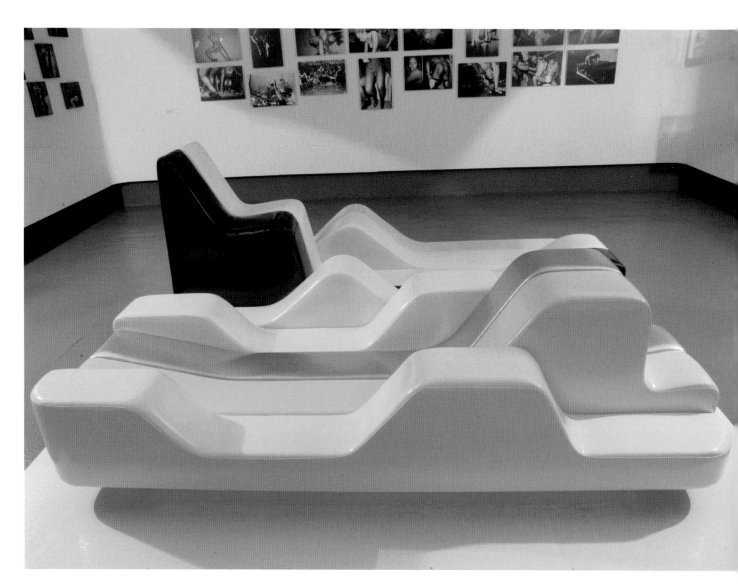

Karim Rashid. Karim Sutra, in the New York Museum of Sex

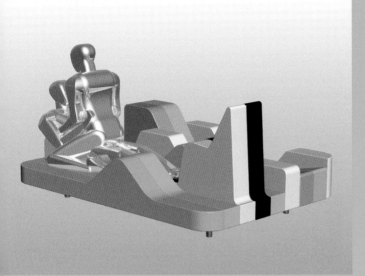

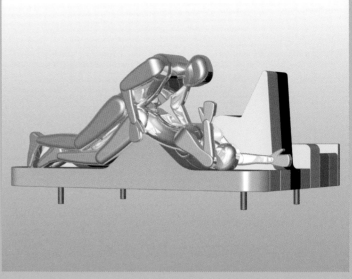

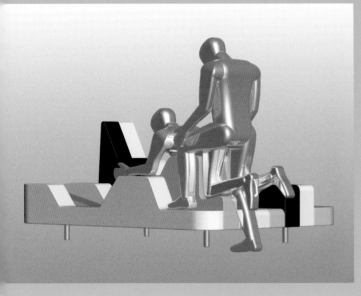

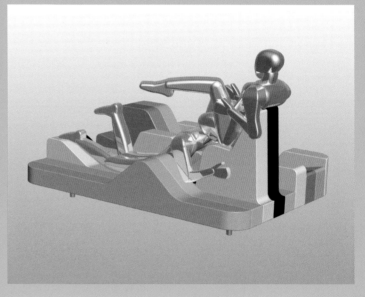

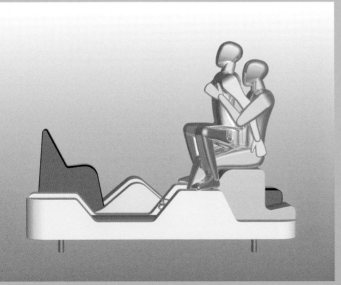

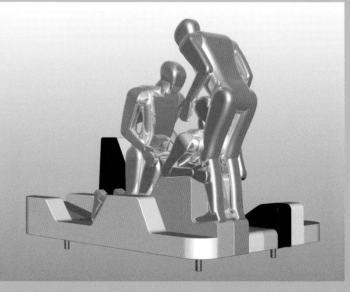

Karim Rashid. Karim Sutra

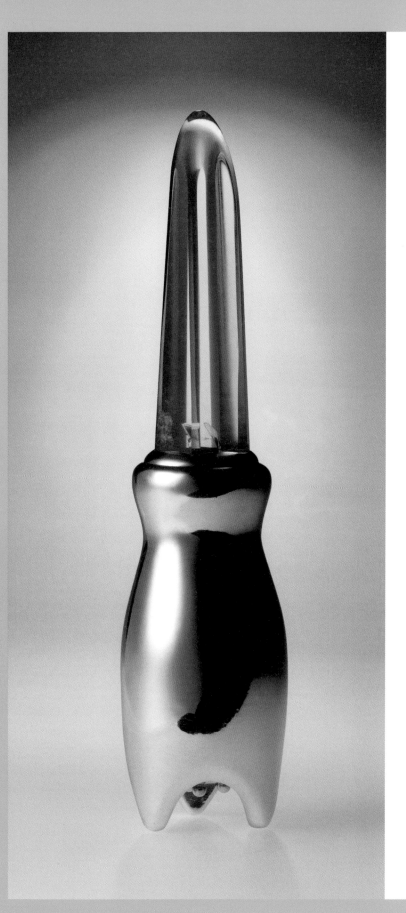

As Mel Brooks has said, in all of his comedic genius, "It's good to be the king (or queen, for that matter)!" Stories of sexual desire and satisfaction abound in the history of royalty, from sordid extramarital affairs to orgies and more than a fair share of stranger sexual appetites. Kings and queens of yore would have loved **Shiri Zinn**'s line of regal, erotic toys. Zinn's clientele includes many celebrities and even some true royalty. Her work blurs the line between art and function, and brings the utmost class and refinement to an industry often reserved for oversized rubber penises or pink plastic nondescript phalli. Every one of these pieces is just as comfortable displayed under glass or on a mantelpiece as it is under the sheets.

Shiri Zinn. Crystal Dildo

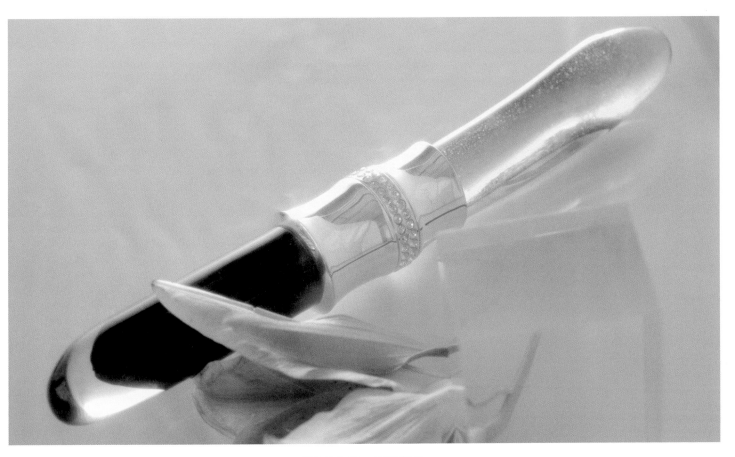

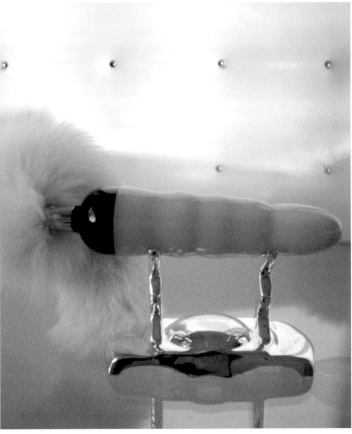

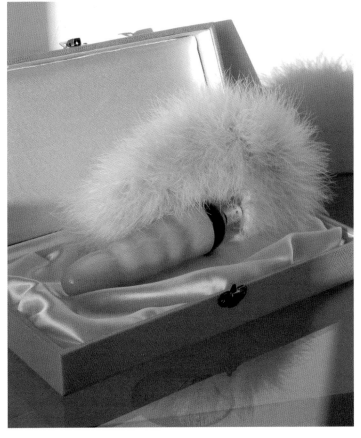

Shiri Zinn. Double Dildo Design

This little guy, **Lucky Duck**, is a true rubber duckie inside and out. The designer, and doctor, **William Pordy** created him as a fun and floating way to always keep your condoms at hand.

William Pordy. Lucky Duck Condom Carrier

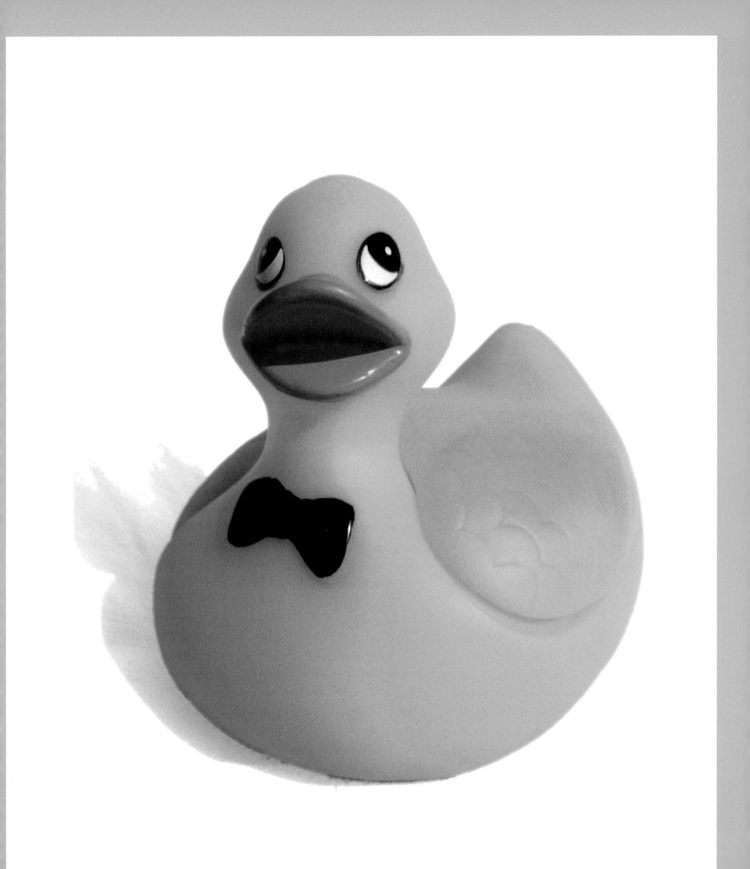

William Pordy. Lucky Duck Condom Carrier

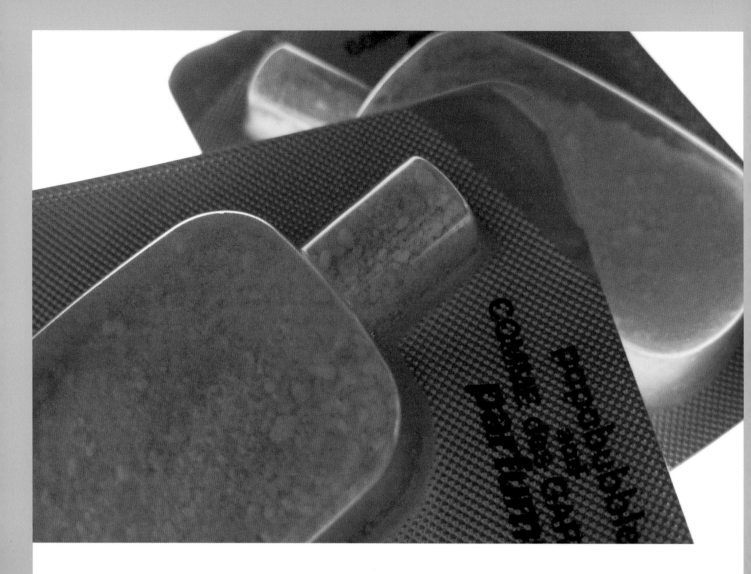

Candy . . . The act of sucking has been pleasurable to both men and women since birth, and no one outgrows it. **Papabubble** has embraced this fact, and its large, finely textured lollipops are a fix in more ways than one. The package they designed with **Comme des Garçons** is single-serving, but the sweet, slightly tangy powder it contains is not. Remember to dip.

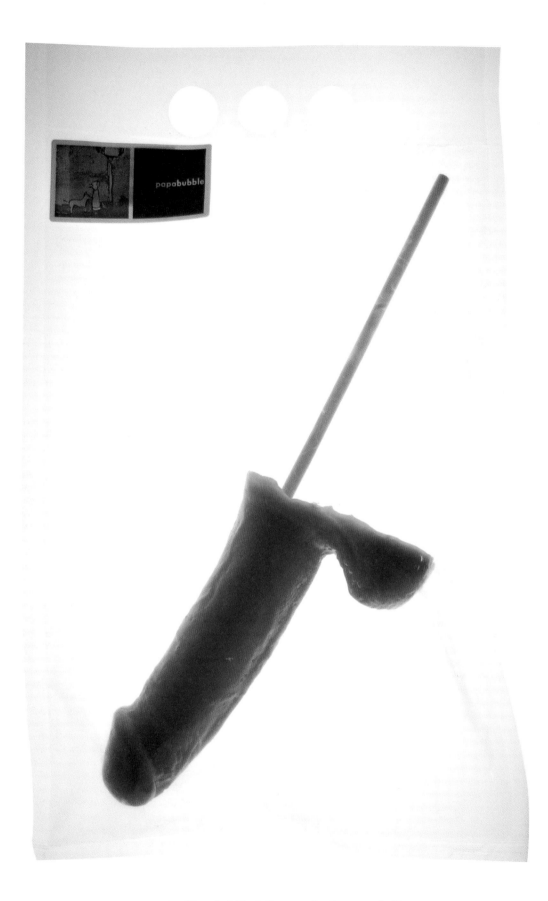

Papabubble / Papabubble & Comme des Garçons. Lollipops

60

→ **LOOKING AT IT**

Wait, is that? No, it couldn't be. . . We've all seen a piece of art or graphic design we just can't peel our eyes away from because there's the slight possibility we might have seen a breast or a penis hidden in it somewhere. It's just inevitable: sex interests us and draws our attention like nothing else. The problem is that all too often when eroticism shows up in the picture, taste and style are left to sleep on the sofa.

Despite the fact that art history is overflowing with erotic and sexual themes, contemporary work of this kind is often dismissed because of its tackiness. However, there still are artists who continue to carry the torch and create works that are at once visually provoking and conceptually interesting, and have an audience that knows that the simple heading of "erotic art" just won't cut it.

Illustrative and graphic styles, as well as the various media these artists use, help artists' bring the work to their audience in a democratic, although at times aggressive, way. This is when eroticism, taste, and style all come together perfectly, and no one is left sleeping on the couch.

We've all seen massive billboards with half-naked girls implying that they might sleep with us if we use a certain type of motor oil or get a certain life insurance policy, but what would our reaction be if we ran into these images on the street and they weren't selling us anything? Shock? Disgust? Confusion? Amusement? Or simply appreciation? The Belgian artist collective **Cum** has been posing that question to people all across the world as the artists stick up their graphic posters and stencils made with the help of the copious amounts of pornography available on the Internet. Their **Fucking Erotic Street Entertainment** is an exercise in their freedom to put up sexual images without a million-dollar ad campaign backing them. Taking the lovely ladies of the Internet out of their natural habitat and letting them loose on the streets is the ultimate play on how context affects our reading of something. From Cum's experience, that reading might just depend on whether or not the lady is posing next to a big corporate logo.

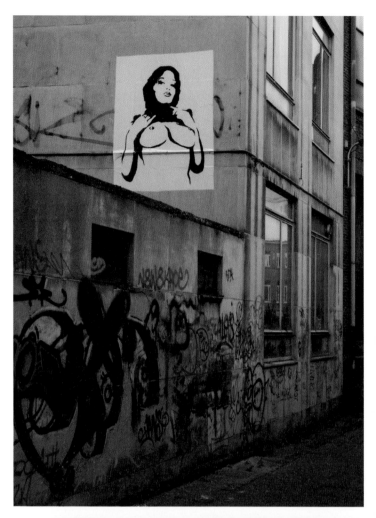

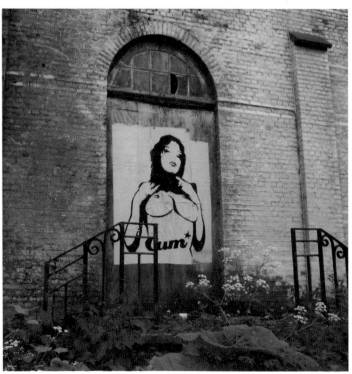

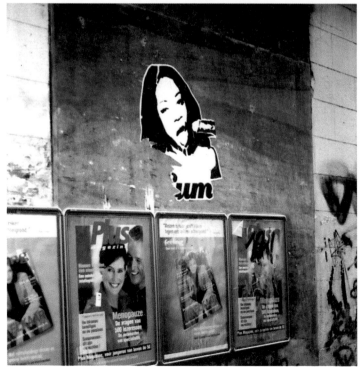

Cum. Fucking Erotic Street Entertainment

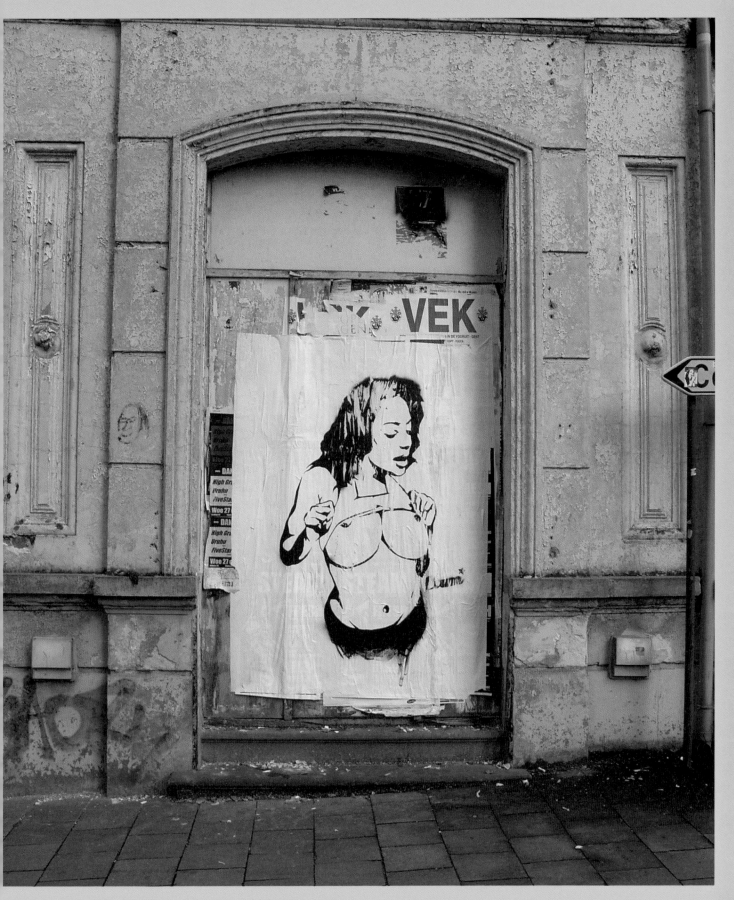

Cum. Fucking Erotic Street Entertainment

Mike Giant. Peonies, Mohawk

The widely renowned and incredibly talented artist **Mike Giant** has had his work span and dominate the worlds of graffiti, tattooing, and skateboarding for well over a decade now. But regardless of his versatility, it still comes as somewhat of a surprise when his work enters new venues and styles such as when he was given the opportunity to exhibit a solo show of his sexual/spiritual drawings at the Hollywood Erotic Museum. These works combine tantric and yogic sensualities and sensibilities with tattooed chicks and a high-contrast punk rock style. These pieces are further proof that you simply can't tie down a diverse talent such as Mike Giant, that is unless he asks you to.

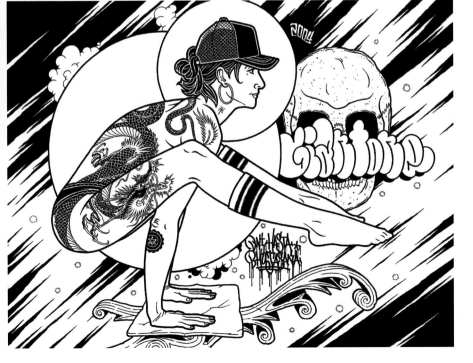

Mike Giant. Aviator, Yoga Position: Dwi Hasta Bhujasana

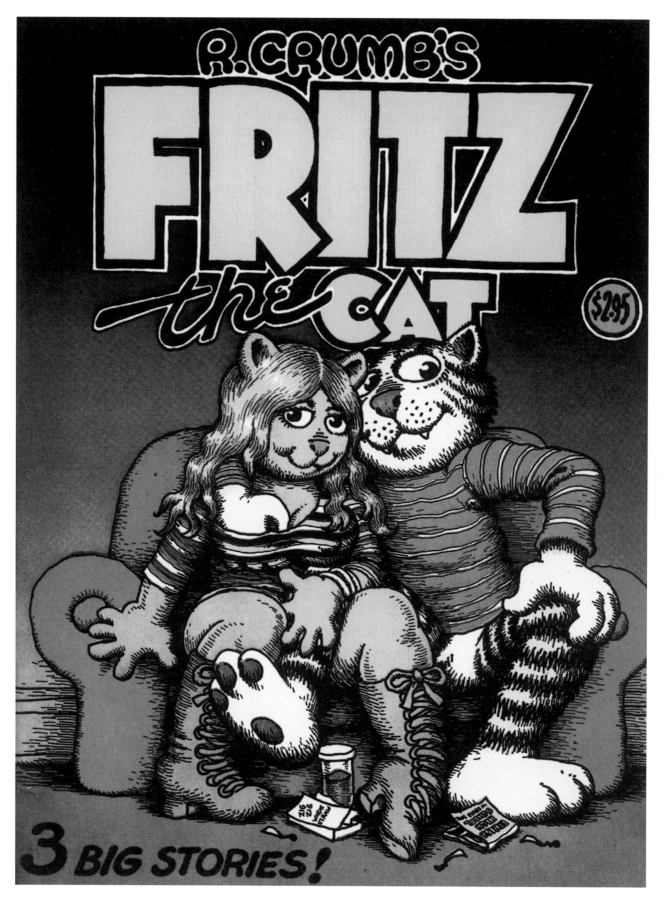

The Artwork of R. Crumb

For nearly 50 years **R. Crumb** has made a prolific career of drawing politically and socially relevant comics that poke fun at our secret fantasies, and he has done it with little or no regard for mainstream comics or the art world. He is a master draftsman and storyteller, and has been compared to Brueghel and Goya by the world-renowned art critic Robert Hughes; but what subject matter does this modern-day master choose to illustrate more than any other? You guessed it, sex.

His comics may at first appear "cute," but more often than not they reveal more than you might like to know about Crumb's sexual fantasies, frustrations, and any other thoughts he has ever had about women and sex. Because he holds nothing back, his work has often been called misogynistic and crude, but this has never stopped him from saying what he wants to say and drawing what he wants to draw.

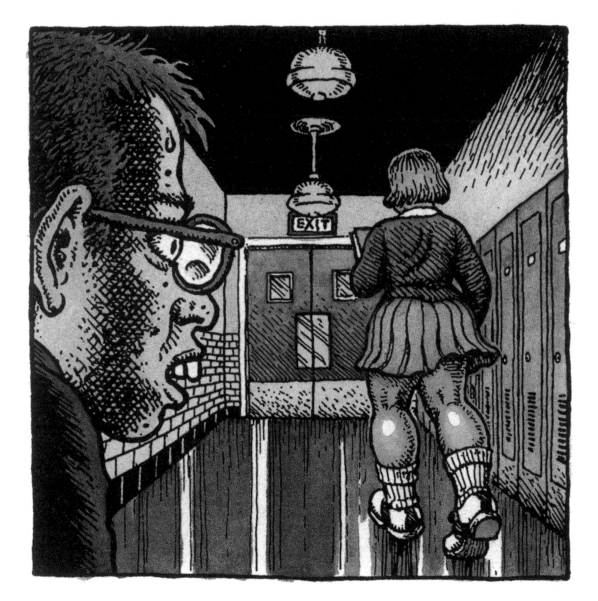

"FIGURE STUDIES" AT THE ART MUSEUM

R. CRUMB '81

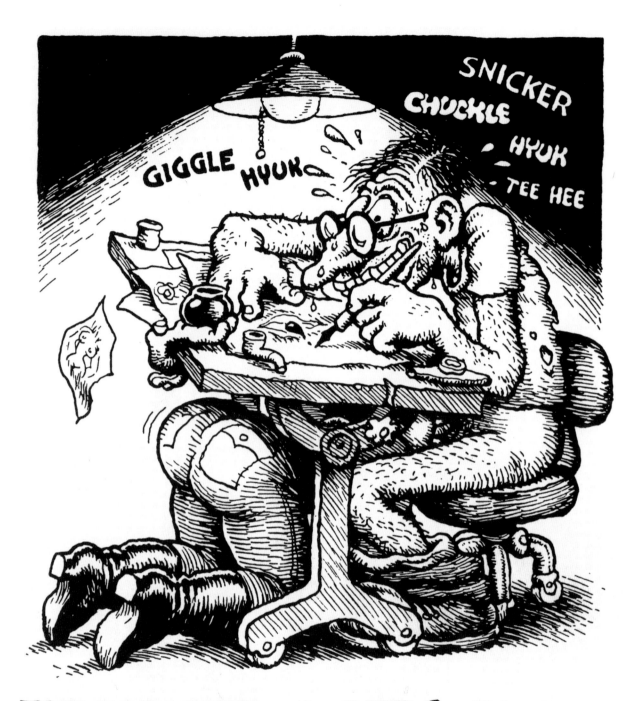

THE PLEASURE IS OURS, FOLKS!

WE REALLY *LIKE* DRAWING DIRTY CARTOONS! IT HELPS US GET RID OF PENT-UP ANXIETIES AND REPRESSIONS AND ALL THAT KINDA STUFF... WE HOPE **YOU** ENJOY LOOKIN' AT 'EM AS MUCH AS WE ENJOY *DRAWIN'* EM !!

"WHAT THIS WORLD NEEDS IS MORE SATISFIED CUSTOMERS!"

Where would you find topless knife-wielding Loli-tas, three-eyed monsters covered in slime, dancing fruits, and undead bunnies all living happily under one roof? Only in the world of **Junko Mizuno**, who has made a name for herself with a distinct and recognizable style of manga that is different from almost any other work in this oversaturated market. The imagery she uses is erotic, sinister, and at times grotesque, but because of her ultra-cute style it's impossible to be repulsed by it. Her work has been featured in American magazines such as *Tokion* and *Beautiful/Decay*, and she is hugely popular in Japan in every medium from comic books and T-shirts to album covers and nightclub décor. She has also published numerous full-length graphic novels—including her own darker versions of **Cinderella** and **Hansel and Gretel**, as well as original titles **Pure Trance**, **Hell Babies**, and **Princess Mermaid**—in addition to many collections of her illustrations.

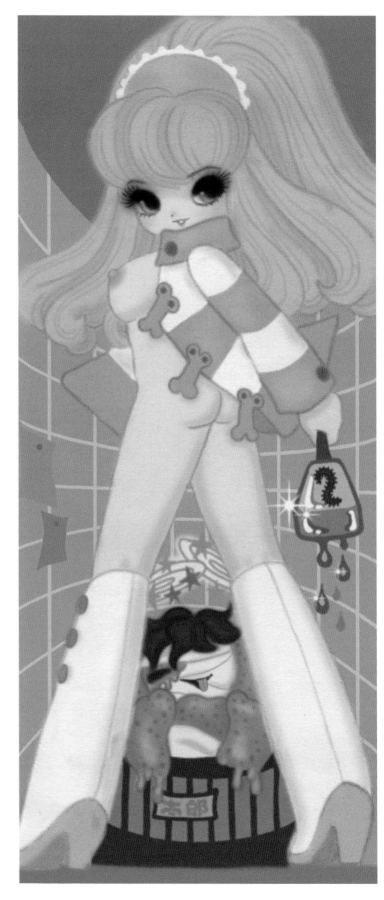

The Artwork of Junko Mizuno

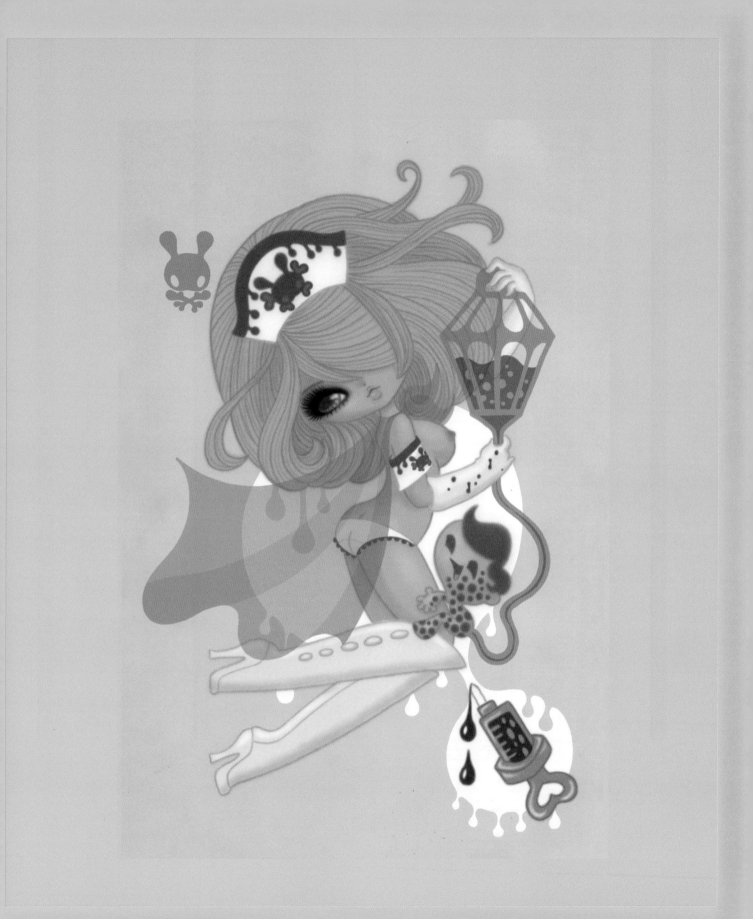

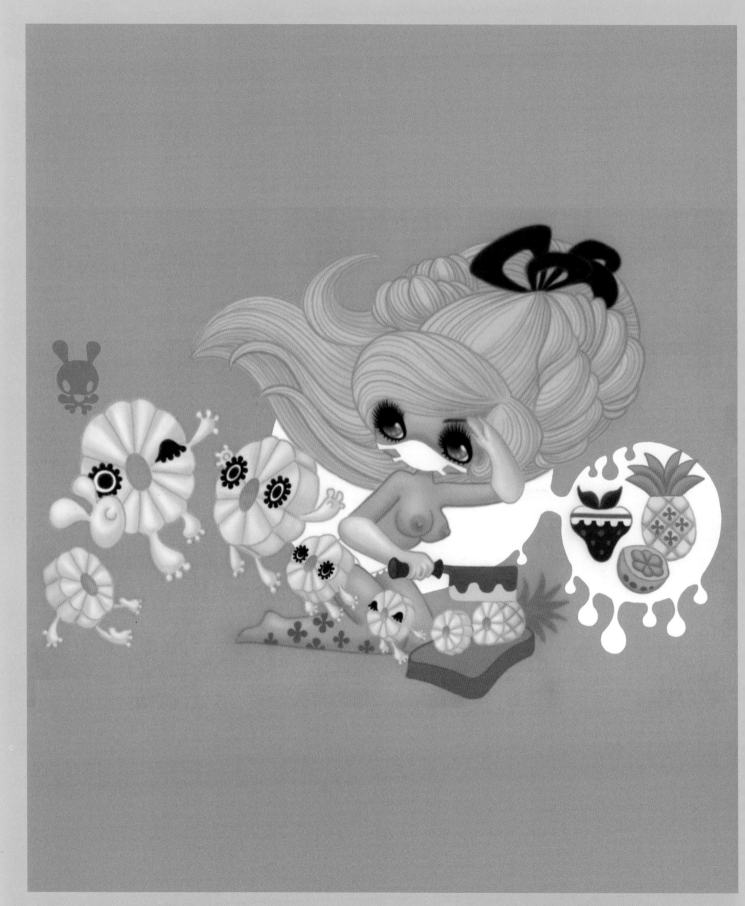

The Artwork of Junko Mizuno

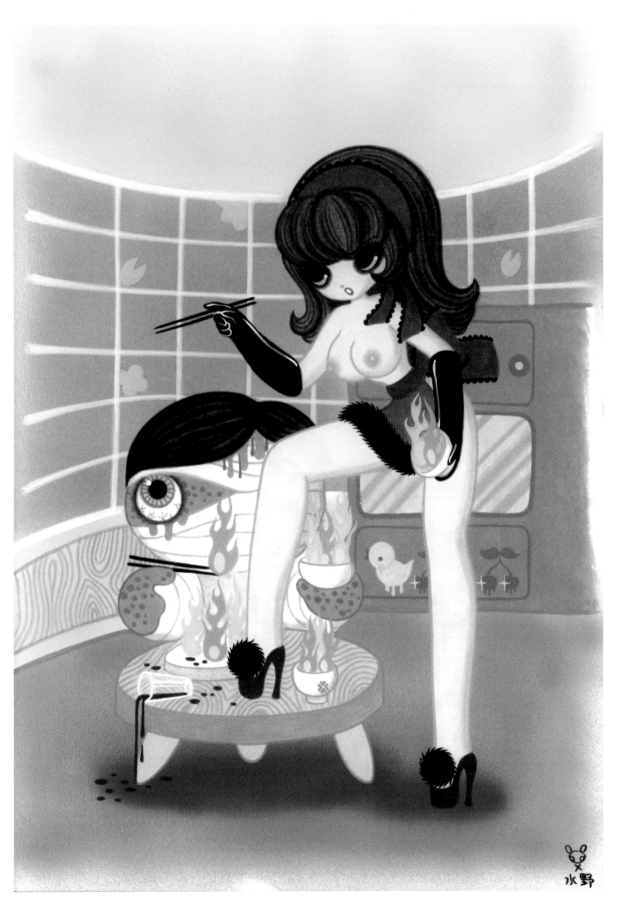

The Artwork of Junko Mizuno

With computers revolutionizing how images are created and viewed, our whole world has turned into a series of pixels and vectors. Where the masters of yesterday may have used pen and paper, today's Goyas and Daumiers seem to be more inclined to turn to the Wacom tablet and Adobe programs. But regardless of the media, we all know that sex will always be a popular subject for artists and their audiences. Illustrators **Nana Rausch** and **Peter Stemmler**, founders of **Quick-Honey**, have created erotic and amusing illustrations that reflect our sexuality and our new technologies. While in the last century we liked our porn on paper, these illustrations force us to consider our new digital obsession.

Peter Stemmler (vectors). Sexual vector icons and illustrations for QuickHoney

Nana Rausch (pixels). Sexual vector icons and illustrations for QuickHoney

They say men think about sex every six minutes and as for football . . . Eight hours of work in front of the computer with one of **Pat Says Now**'s **World-cup Girls** or the **Body Mouse** gives them everything they want at their fingertips. The Swiss-based designers **Patrick Strumpf** and **Dirk Ruenz**'s stylish computer mice stand out from the crowd and are directed to the basic lower instincts. Every detail of the mouse is carefully checked before production, from the size of the breasts to the velvet on the mouse

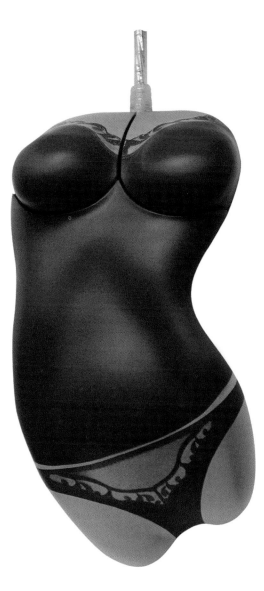

Patrick Stumpf and Dirk Ruenz. Mouse Designs for Pat Says Now

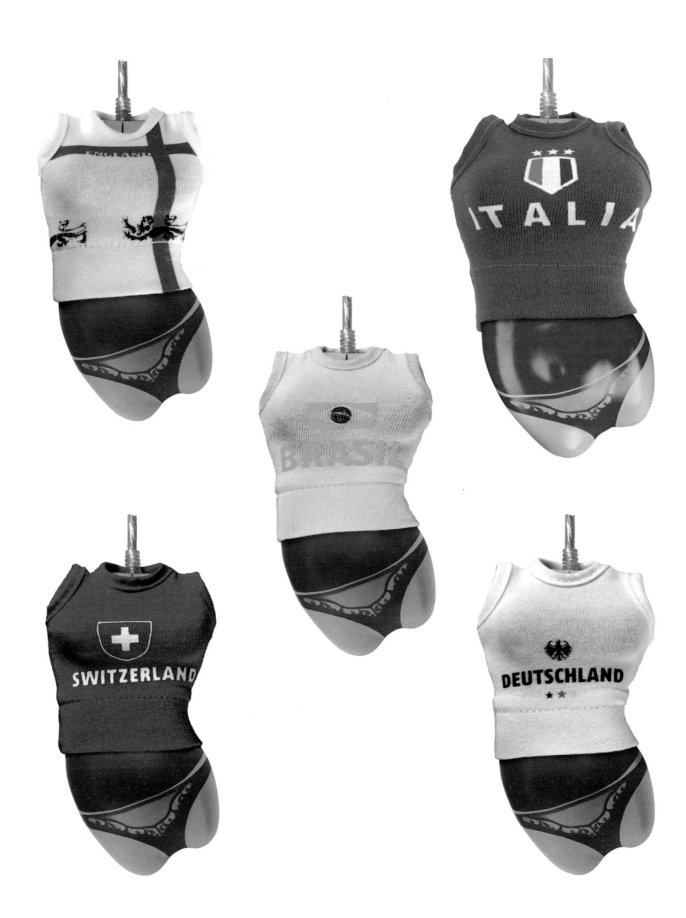

Patrick Stumpf and Dirk Ruenz. Mouse Designs for Pat Says Now

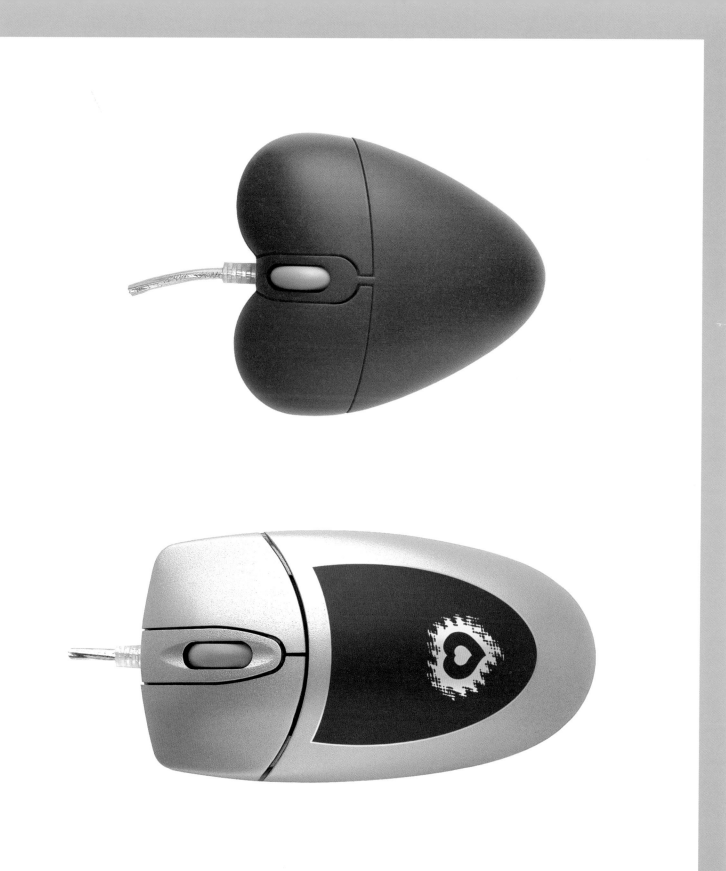

Patrick Stumpf and Dirk Ruenz. Mouse Designs for Pat Says Now

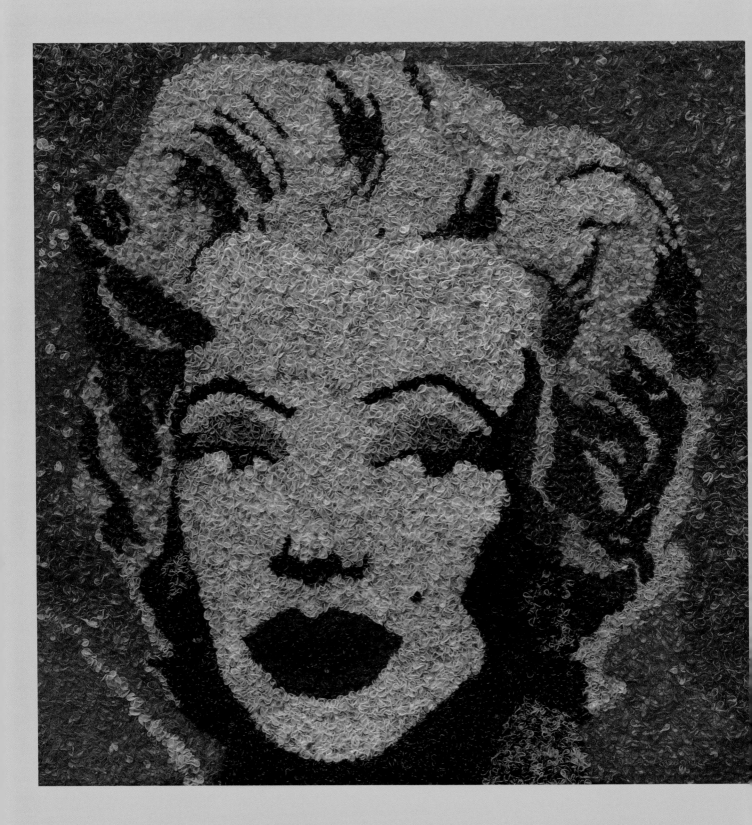

Adriana Bertini. Marilyn Monroe Condom Painting

"Pop" isn't what you want to think of when you think of condoms, but the two ideas go together perfectly when we're talking about **Adriana Bertini**'s interpretation of the classic Pop Art portrait of Marilyn Monroe. Using nearly 100,000 condoms to create this massive iconic image, Bertini has combined a classic sex symbol with a contemporary and very significant piece of today's popular culture, the condom. Her work addresses the very serious subject of safe sex and the spread of HIV and AIDS, but does it in a pleasing and attention-grabbing way. She claims this is her way of opening honest discussion of the topic among people all across the world and, judging from the fact that she has exhibited her work and held lectures in five continents, she truly has brought that message to a global audience.

Adriana Bertini. *Marilyn Monroe Condom Painting*

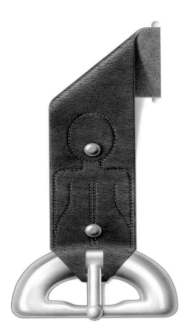

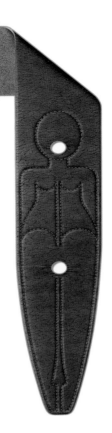

Sex sells anything: its been the driving force behind the proliferation of technologies from VCRs to home camcorders and much of Internet technology. The prolific and world-renowned erotic artist **Julian Murphy** has created his own art movement, affectionately called Tantric Pop Art. His work combines familiar images of products and brands with erotic subject matter that people are often hesitant to talk about openly. These are examples of visual communication at its finest. The complexities of the subject matter are made digestible in a light and familiar way, but without diluting the subject matter. Each piece stimulates the eye and the mind, and as the artist himself says, "Your most erogenous zone is your mind."

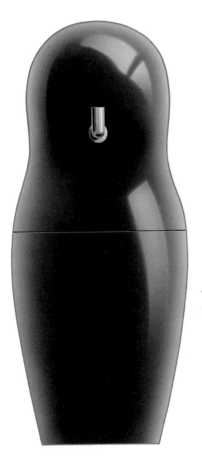
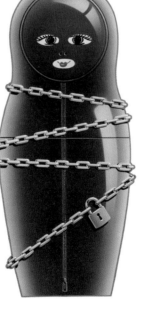

82 **Julian Murphy**. Belt, Russian Dolls

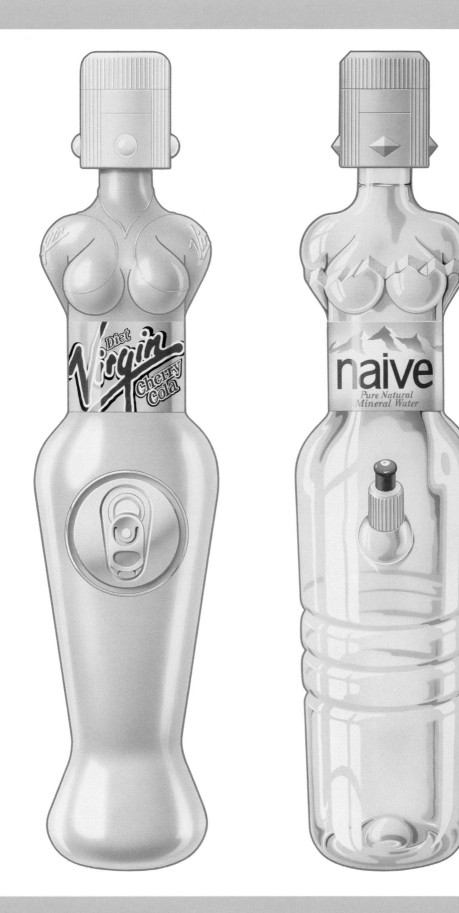

Julian Murphy. Clothespin

Julian Murphy. Gender Guitar, Safety Matches

Julian Murphy. Dividers, Swiss Army Knines

Porn pops up everywhere. It pops up on the computer screen when you search on the Internet, it pops up in your local newsstand and on the TV late at night, and it has even popped up in video games. So would you really be upset if you suddenly encountered a little porn on your birthday? The British design team **Suck UK** didn't think so. Their **Raunchy Wrapping Paper** took the classic idea of replacing boring old wrapping paper with pornography and added an extra element of surprise to it. When opening the present and revealing the graphic on the inside of the paper, the lucky recipient is treated to a double surprise., Aand now that the boys' version has been released, no one is left out of the fun.

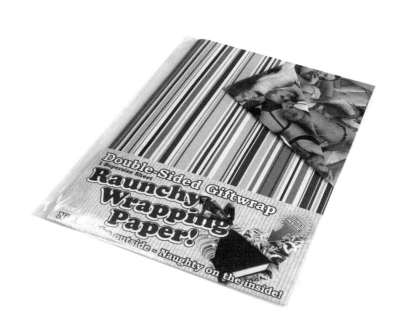

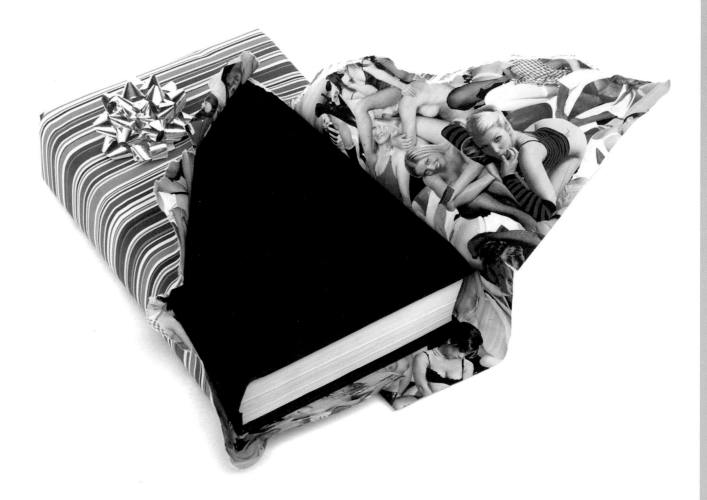

Philip Foeckler. Love You to Death

When it comes to visual communication simpler is often better, especially if the image is to be read quickly, such as when passing it on the street. Designer **Philip Foeckler** created the logo for this viral sticker campaign in San Francisco to raise awareness about the HIV and AIDS epidemic. In a clear and attractive way, this graphic logo illustrates and informs about the clear relationship between sex, love, AIDS, and death.

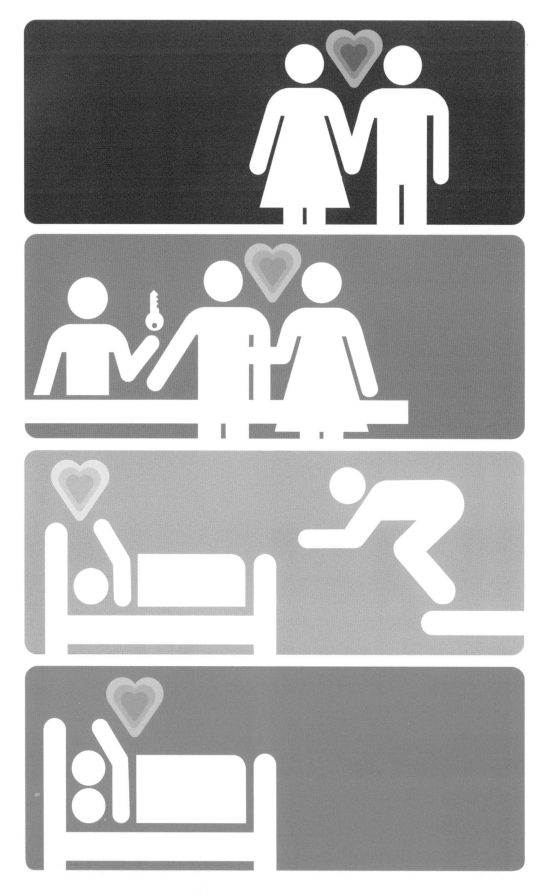

José Luis Merino. Hotel La Paloma Ad Designs

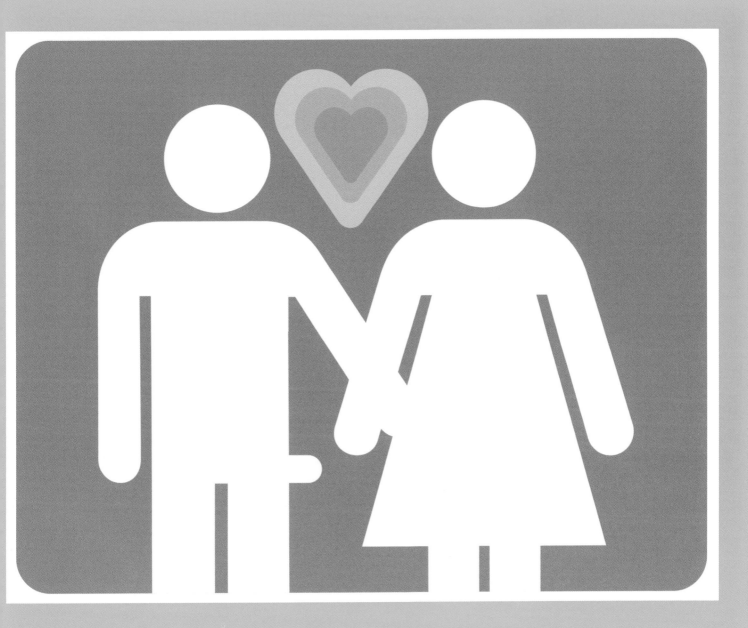

When the **Hotel La Paloma** in Barcelona contacted the illustrator **José Luis Merino** to design a series of illustrations and graphics for them, he was more than a bit surprised and excited. Having worked with the likes of *The New York Times*, BMW, Neiman Marcus, and the Ritz-Carlton, he realized that the Hotel La Paloma did not seem like his normal client. You see, the Hotel La Paloma is the type of hotel you don't usually spend more than a few hours in, and probably would only go to if accompanied by a lover. But in an attempt to change the prejudices about these sorts of places, the hotel has turned to the world of design. And with these simple, cute, and matter-of-fact graphics, they might just begin attracting a whole new sort of clientele.

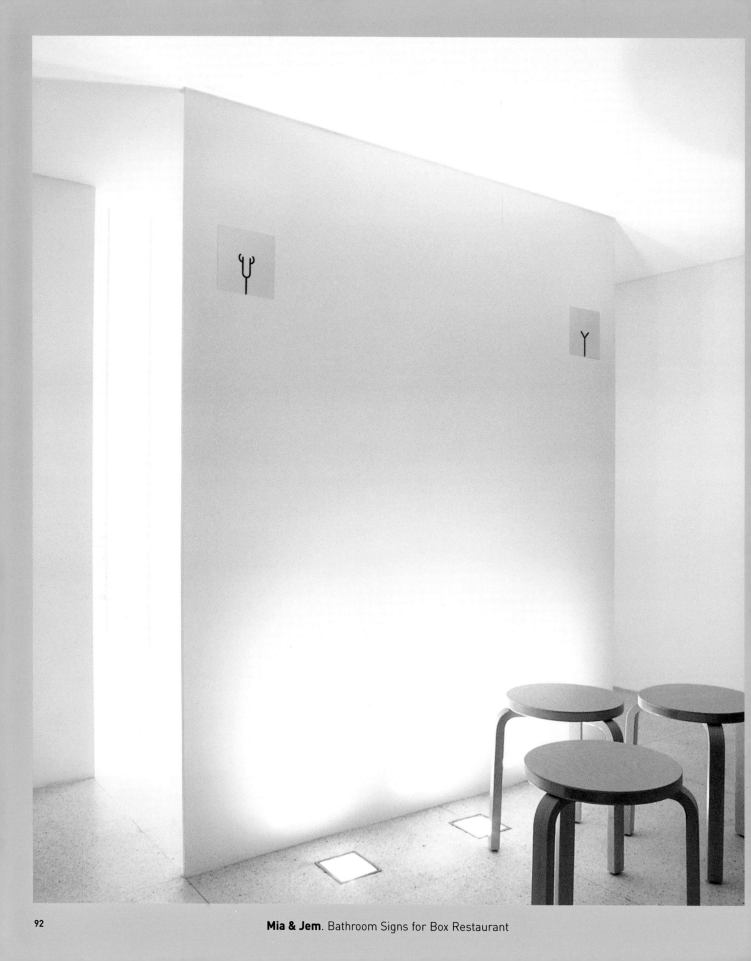

Mia & Jem. Bathroom Signs for Box Restaurant

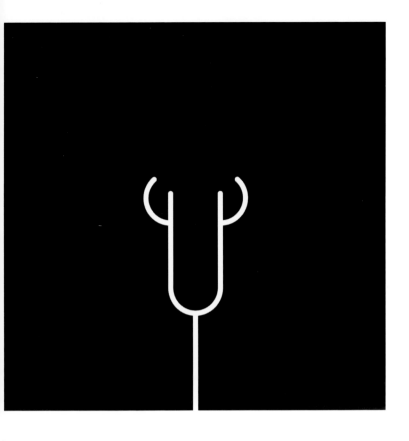

Since Otl Aicher created the universally recognized bathroom pictographs for the 1972 Munich Olympics, there has never been a more successful and universally accepted version. But this doesn't mean that locations throughout the world don't try something different from time to time. The only problem is that originality may be confusing and could possibly cause some very uncomfortable situations for foreigners desperately needing to relieve themselves. When the **Box Restaurant** in Australia decided to hire Mia Daminato and Jeremy Matthews, of the design firm **Mia & Jem**, to create their identity, they wanted signage that stood out from the norm while remaining universally readable. Following the most effective design principle of simplicity, the pair created these original restroom logos that symbolize the difference between the sexes, as well as the difference between their client and other restaurants.

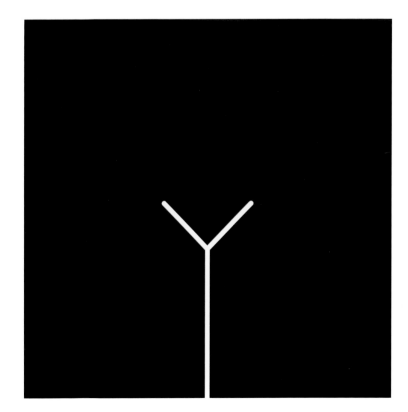

Mia & Jem. Bathroom Signs for Box Restaurant

94

→ LIVING WITH IT

Most of us go through our everyday lives without noticing a fraction of the sexual innuendos that constantly surround us. But they are everywhere.

Did you even raise an eyebrow when you popped the bread into the toaster this morning (or perhaps when it popped back out)? Are you as excited to see the massively erect skyscrapers as they are to see you? Even if you haven't tuned your brain into the sexual entertainment channel that's playing 24 hours a day seven days a week all around us, there are more than a few designs out there that might just flick the switch for you. So whether you're at home or on the streets, make sure to keep your eyes open and your hands out of your pockets. Well, maybe you can leave them there.

We encounter sexual metaphors of all kinds in our daily lives, such as when sucking from a bottle of water or pumping gas into our cars. But the most common would have to be when we take out that little phallus of a front-door key and insert it perfectly into our eagerly awaiting locks. We usually overlook the sexual nature of these acts because of how common they are, but occasionally their cover gets blown wide open. The British designers **Jamie and Mark Antoniades**, founders of **J-Me** design firm, created the **His/Hers Key Holders** as a light-hearted product that lets you know exactly where to stick it. These designs perfectly illustrate that all it takes to remind us of the underlying metaphor behind every protrusion and hole is to stick a pair of legs on it.

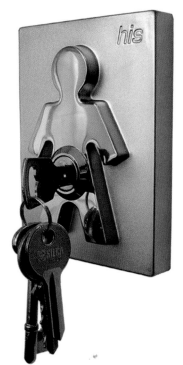
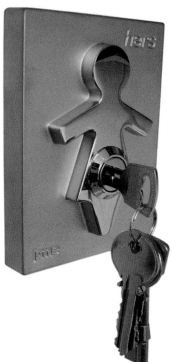

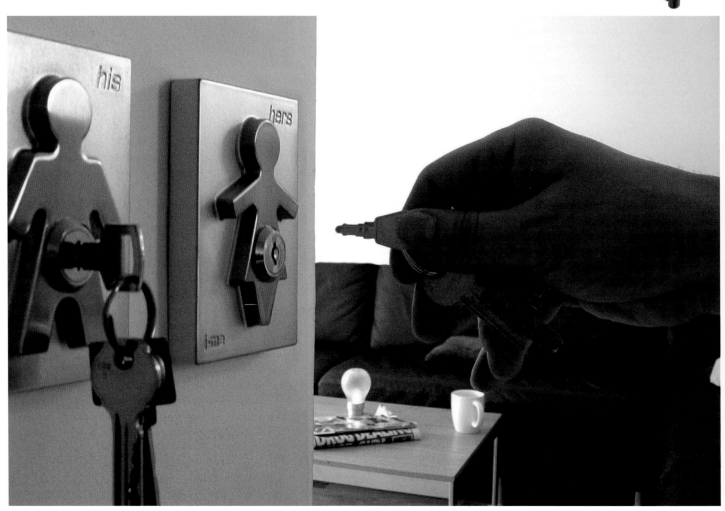

Jamie and Mark Antoniades. His/Hers Key Holders for J-Me

The porn industry has a Mecca and that Mecca is the San Fernando Valley in Los Angeles. For decades William Bergmann, veteran publisher of porn magazine Velvet, lived and worked there in which time he stockpiled tens of thousands of slides of everything from the casting calls to the after parties. He eventually donated the entire collection to the Erotic Museum in Hollywood, at which point they invited the digital artist and designer, **Eric Singley**, to create unique pieces using the slides. Among others he created the **Turn On Floor Lamp**. Because the images are on slides they can only be seen when the light is turned on, which Michael Jonsson saw as a metaphor for the Valley. "There is all this sex going on there but you just don't see it unless the circumstances are right."

Eric Singley. Turn On Floor Lamp for the Erotic Museum in Hollywood

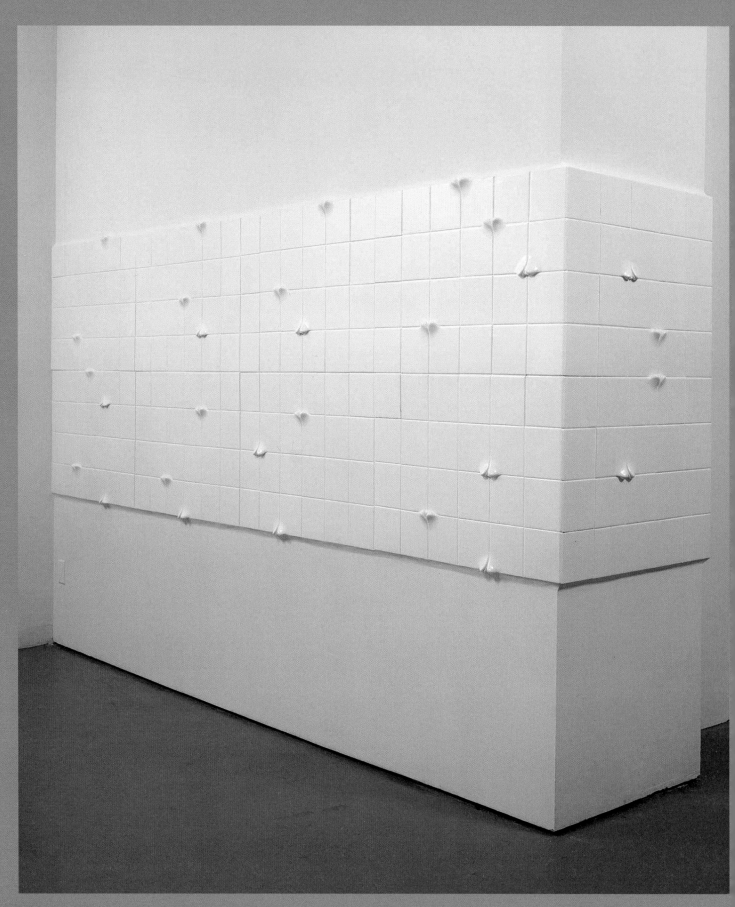

Analía Segal. Blobb Tiles

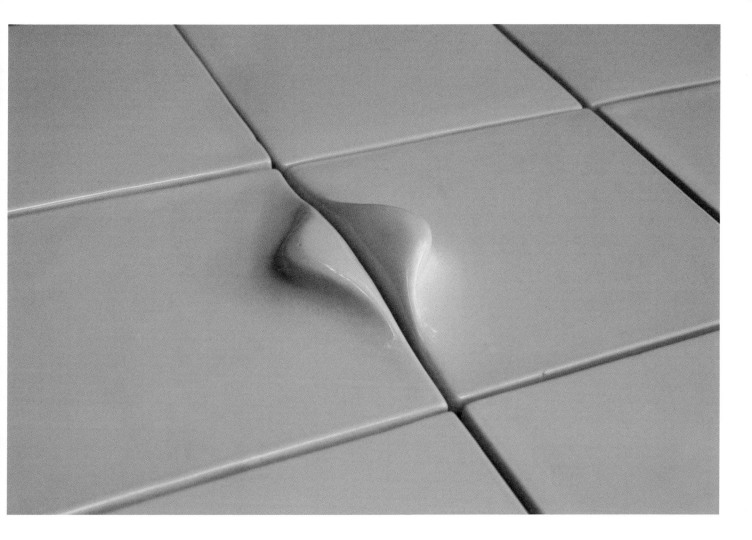

Subtle artistry and design can be found throughout our daily lives, including such examples as the blown glass that becomes our vases and pitchers, the metalworking on our gates, and the ceramic tiling on our floors and walls. But this artistry doesn't need to be gaudy and large to grab our attention. The subtle **Blobb Tiles**, created by **Analía Segal**, gently probe their way into our space and force us to take notice. The anatomical shapes of the tiles may not seem overpowering at first, but when they come together and begin to interact with each other, their presence can't be ignored and they demand at least a quick caress. These outstanding creations won first prize in the Tile Contest at London's 100% Design Show in 2004 and have been exhibited in the Museum of Modern Art in Buenos Aires, as well as in various museums in New York City. But where the tiles' tiny protrusions make the most impact is in their natural habitat on the walls and floors of our daily spaces: another reminder that size doesn't necessarily matter.

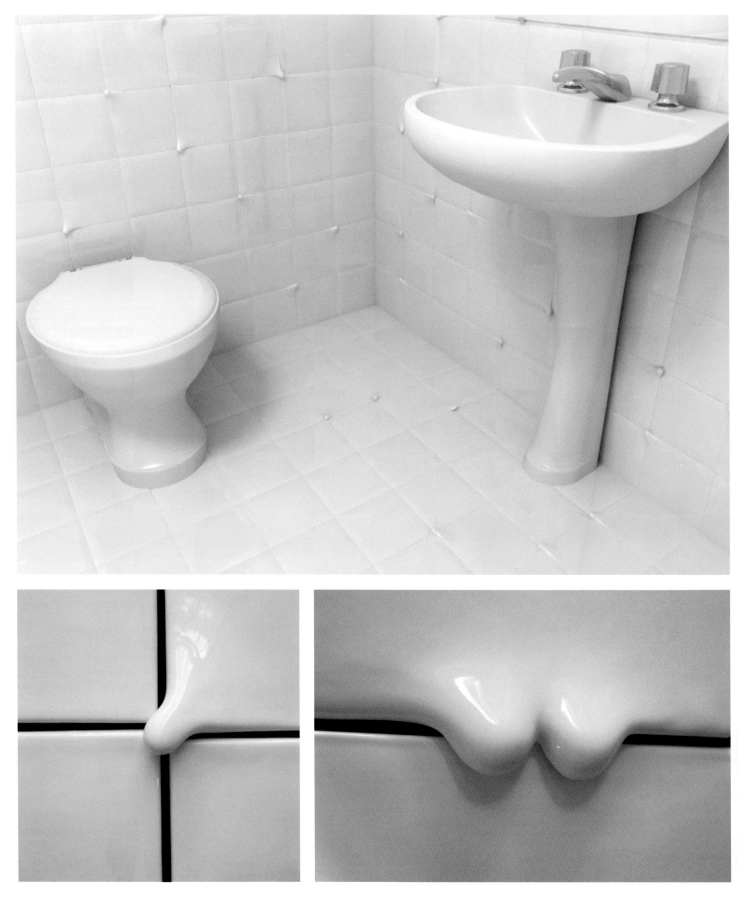

Analía Segal. Blobb Tiles

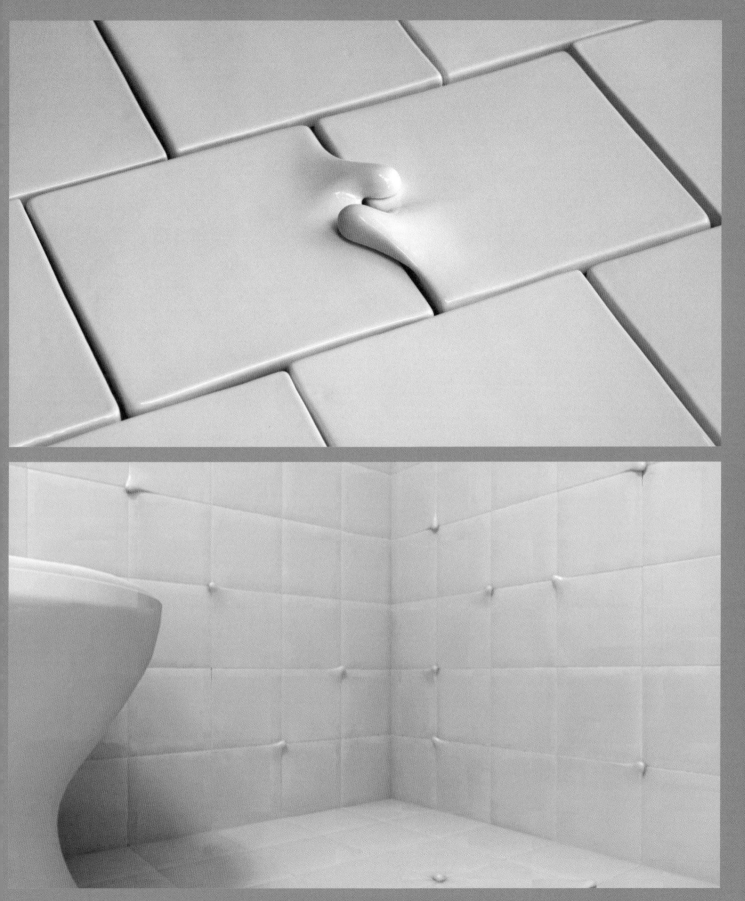

Analía Segal. Blobb Tiles

Look around your living room: what does your furniture say about you? Is it comfortable and light? Hard and angular? How we decorate our homes changes how people react to and interact with the space. What do we do if we want to create an environment that's inviting, unique, and comfortable, and that also shows good taste? As has been proved throughout history, sex is a surefire way to get a reaction, but without a sense of design it's more likely that sexual furniture will disturb your guests rather than exciting them. The artist **Julian Murphy** has brought us furniture that teases our erotic and sensual side, while at the same time fully satisfying our lust for good design. He has romantically remixed the classic Isamu Noguchi Coffee Table, as well as created a sofa that might be interacting with you as much as you with it. These are pieces that encourage a lighthearted atmosphere, while at the same time bringing sexual themes out into the open and into our living space.

Julian Murphy. Casting Couch

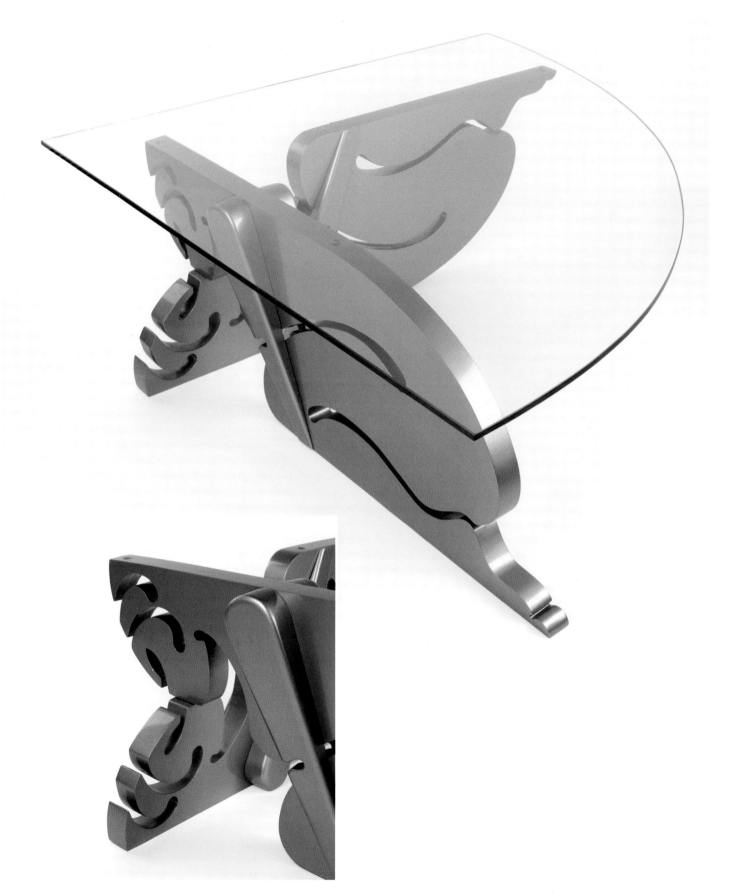

Julian Murphy. Kissing Couple Coffee Table

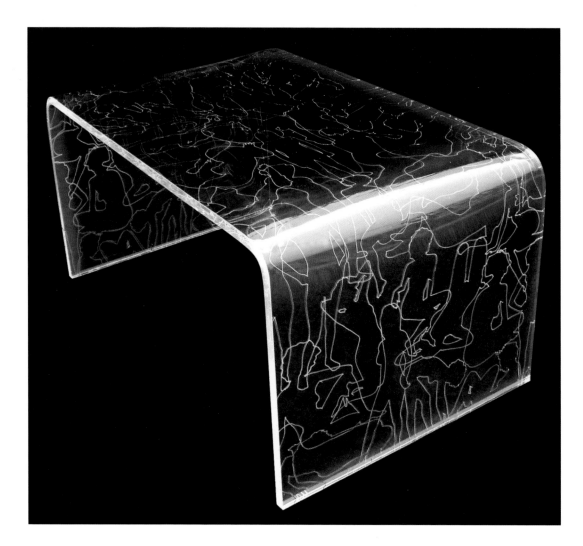

The study of the human figure, usually with at least an undertone of eroticism, has always been a huge part of art history. The tradition of life drawing has been practiced for millennia, and will remain a critical part of any art education forever as far as we can tell. As most art students will probably agree, the first time you walk into a life drawing class and the model drops his or her towel, the room immediately fills with a quiet sense of excitement, curiosity, and nervousness. **Ben Wilson**, a cofounder of **Brothersister** design firm, took this feeling and re-created it for everyday use in his **Sofia Table**. After graduating from art school, he was inspired by the large collection of drawings he had amassed to convert his sensual treatments of the figure from loose charcoal and pastel drawings into clean graphic illustrations. Wilson's crisp design, etched right it into the table's acrylic surface, achieves an abstract and sexy effect that may similarly infuse any space the table is placed in.

Ben Wilson. Sofia Table for Brothersister

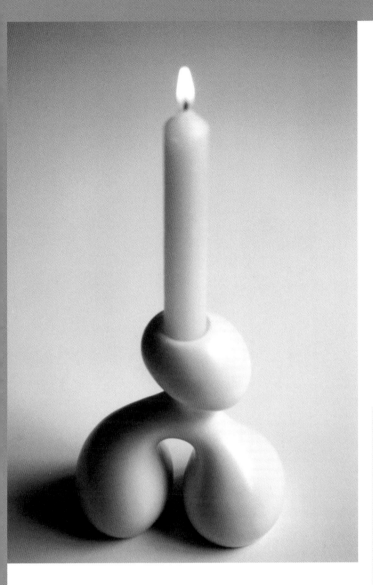

As all artists and designers know, there are times when your work gets read in a very different manner than you originally intended. The **Amoeba Candlestick** was among the first designs **Dominic Bromley** created under the **Scabetti** design brand, and in his search for a piece with as many curves as possible, he made a bit of a Freudian design slip. Like a parent with a child, there comes a time when every designer has to let go and allow his or her work live and grow on its own. These candlesticks have raised themselves well and have made their way into numerous design shows across the United Kingdom and the world. They may also serve as a constant reminder that even if we're not looking for it, sex has a way of popping up all over the place.

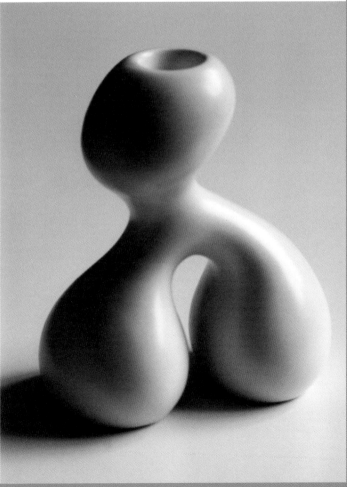

Dominic Bromley. Amoeba Candlesticks for Scabetti

Ingo Maurer's lighting designs never disappoint. Maurer wants to make people feel good and brighten the world with humor and joy. The German-born artist continues to provoke and add fun to the world of design with **Blushing Zettel'z**, a limited edition of the Zettel'z collection. The scribbled paper of the famous interactive paper mobile has been replaced with multiple images of Japanese geisha. Illumination reveals the fixture's name.

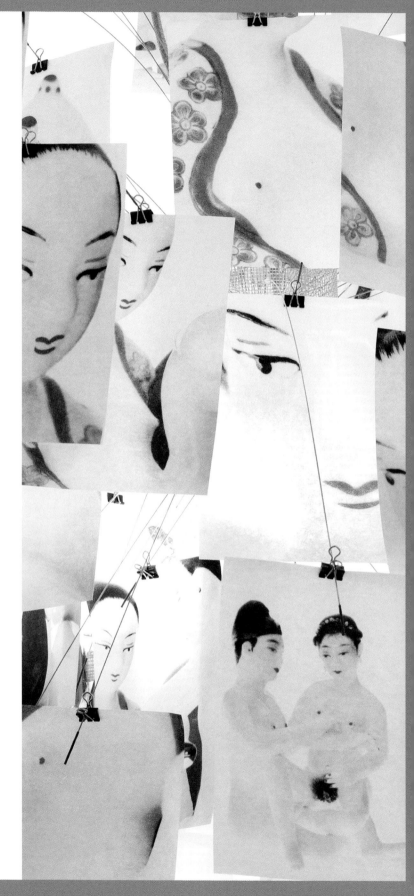

Ingo Maurer. Blushing Zettel'z

Another allusion to the erect male genital: **Carlo Mollino**'s **Erotico** coat hanger. Mollino was an extravagant Italian architect and designer who indulged his erotic fantasies at the time with this design. It was given a new lease of life in 1998 when **Rapsel**, the Italian bathroom designers, included it in their bathroom catalog.

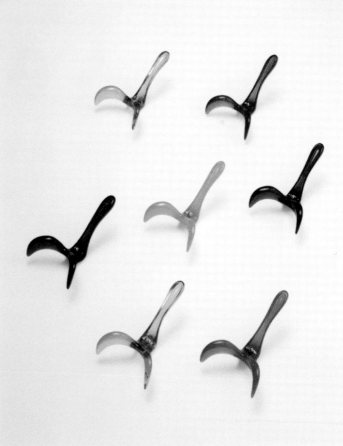

Carlo Mollino. Erotico

Cinzia Ruggeri translates her love of lavish shapes and bizarre stories into designer objects. **Eva's Family** is a perfect example of this. A collection of various items inspired by the shape of the delicate female hand, it is produced in a soft synthetic material available in red, blue, or black. The range includes a handheld shower, a jewel casket, a table lamp, a standard lamp, and a portable emergency light.

Cinzia Ruggeri. Eva's Family

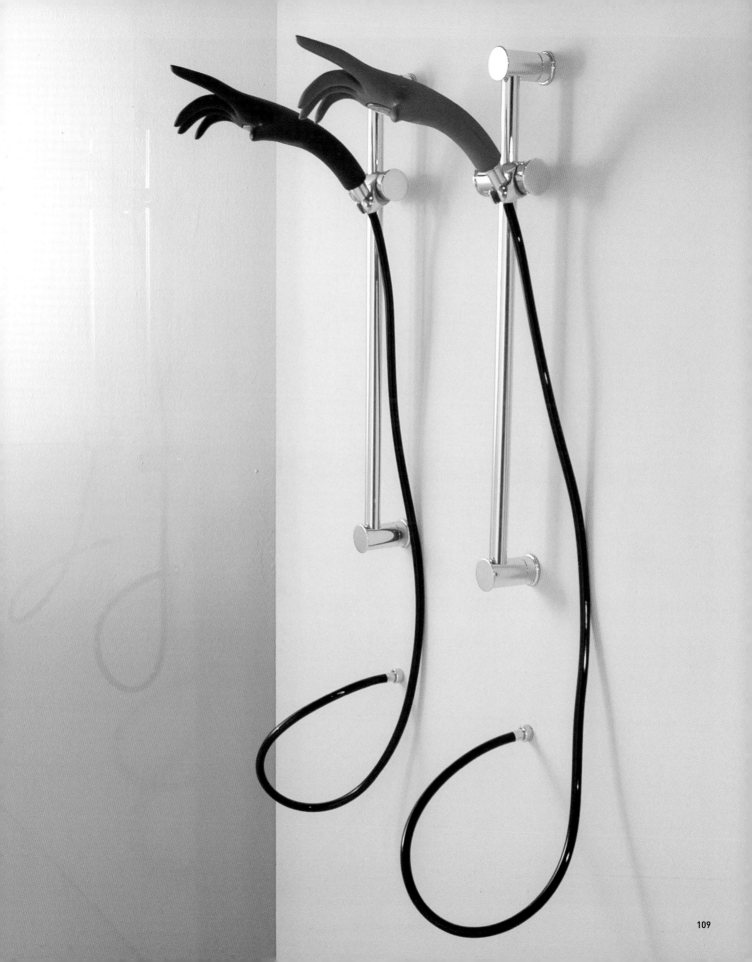

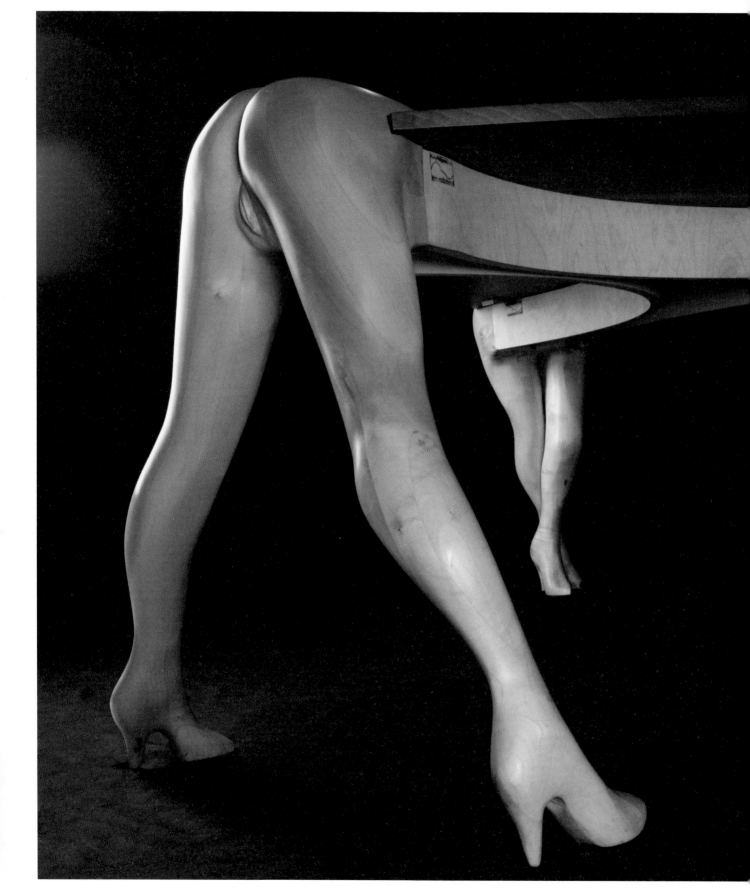

Mario Philippona. Trio Table

When **Mario Philippona** thinks about the female body, he gets wood; actually he gets inspired to build with wood. The Dutch cabinetmaker has been using the ever-stimulating female form for years as the basis for his handmade and very labor-intensive sculptures, cabinets, and furniture. He has taken much inspiration from the classic fetishistic works by the British artist Allen Jones, who created realist sculptures of women as furniture. These works, in all of their fetishistic glory, were built of timber from the finest cherry, walnut, and maple trees, and innovative as well as traditional woodworking techniques were employed. Whether you are a fan of fine woodworking and meticulous craftsmanship, or you just prefer sexual subject matter, these works of art are sure to give you a little wood.

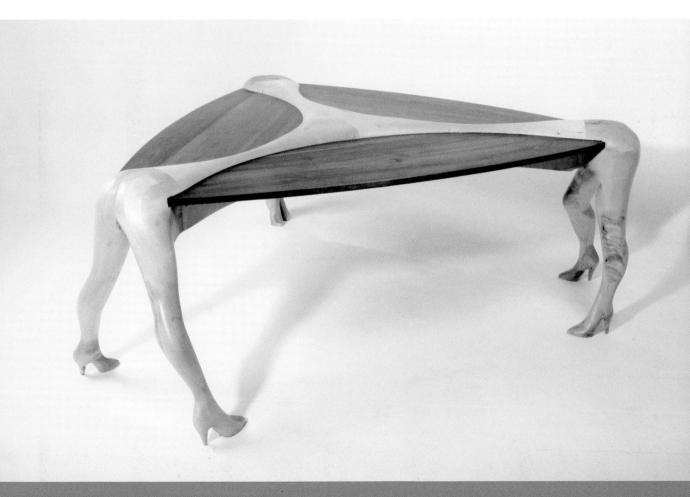

Mario Philippona. Trio Table

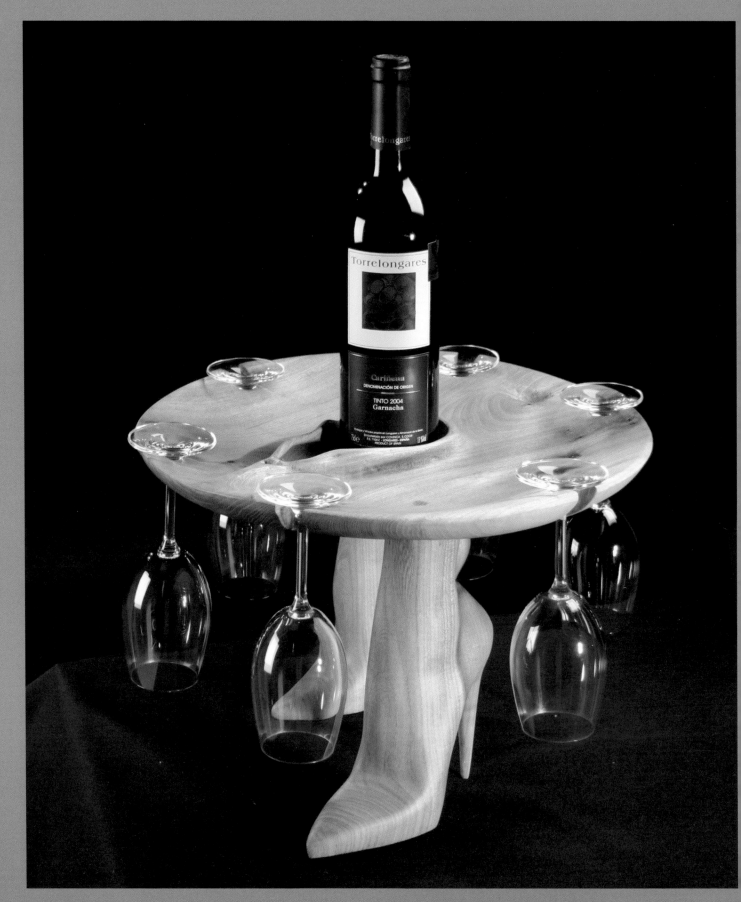

Mario Philippona. High Heel Wine Table

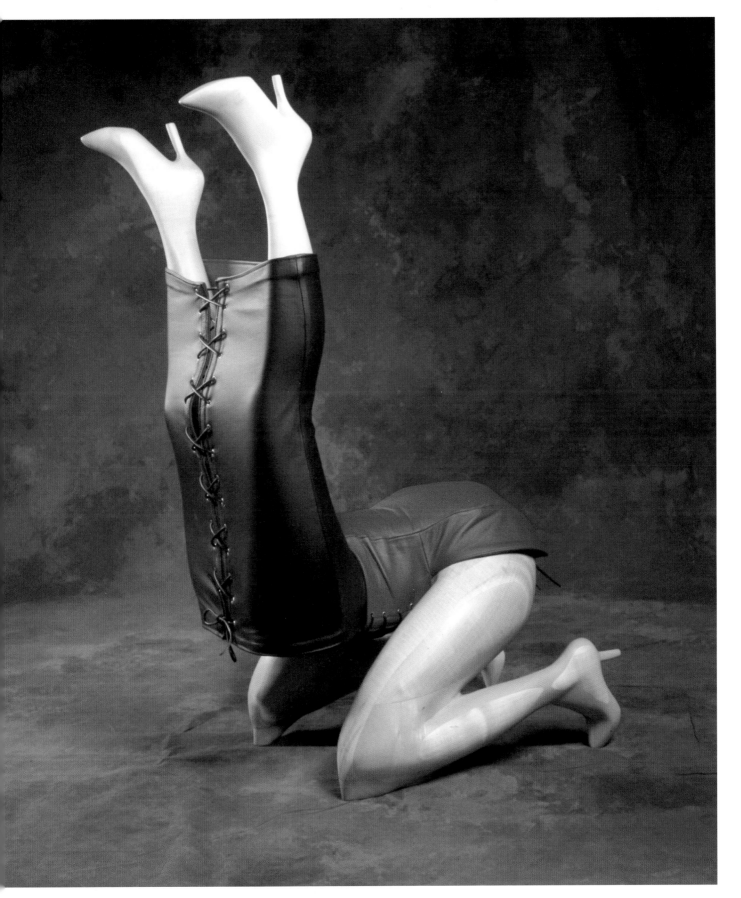

Mario Philippona. 4 legs Chair

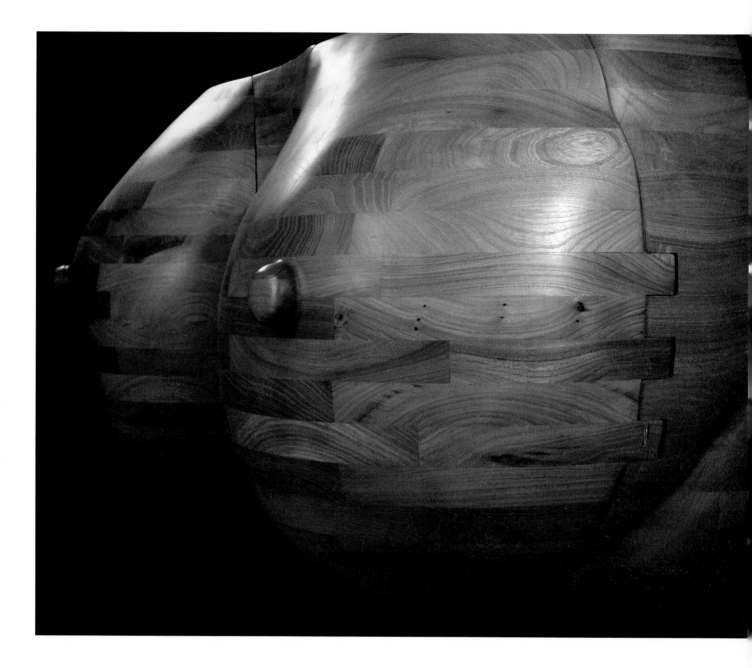

Mario Philippona. Booby Case

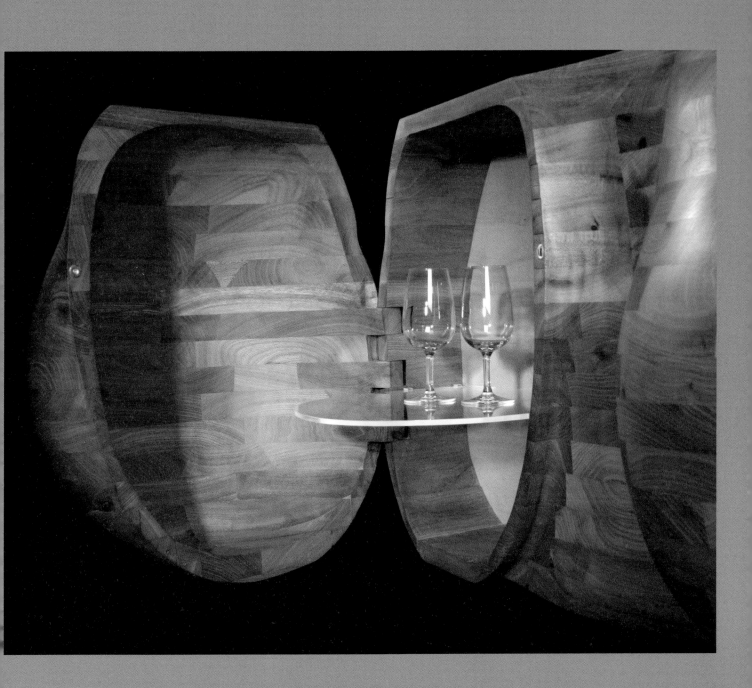

Mario Philippona. Booby Case

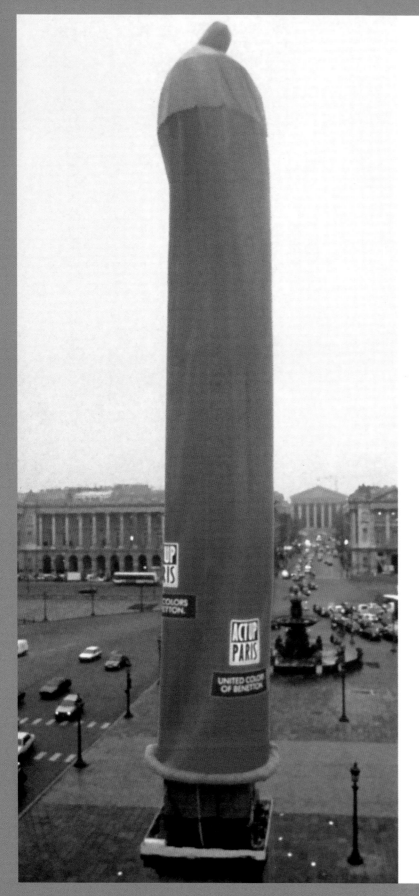

"Holy massive erection, Batman. What's that massive pink condom doing there?!" Shock and confusion would have been a normal reaction for the caped crusader and his partner, as well as anyone else, had they been in the Place de la Concorde in Paris on December 1, 1993, World AIDS Day. The obelisk located there was originally erected to mark the entrance to the Luxor Temple in Egypt, but was transported to Paris as a gift in 1829. In 1993 **Benetton** and **Act Up Paris** turned the structure into a phallic metaphor in order to highlight the enormity of the global AIDS crisis. It received global press for the cause and at the same time sealed the fate of every obelisk everywhere as the suggestive objects they are. The event also inspired a similar demonstration in Buenos Aires on World AIDS Day, 2005, when their most famous city landmark, a 207-foot obelisk, was covered in a similar pink prophylactic.

Benetton and Act Up Paris. Obelisk at Place de la Concorde in 1993

As the ship approached the darkened coastline, the captain could make out an enormous glowing form rising into the night sky. It was radiating hues of crimson and indigo through the haze coming off the Mediterranean. He couldn't make out its exact form, but it was certainly metallic, smooth, and very erect. "What it really looks like," thought our traveler, "is a giant dildo!"

OK, so nobody would actually come across the **Agbar Tower** while sailing through the mists of the Mediterranean Sea (especially due to the amount of other light that the tower's hometown of Barcelona lets off), but it has certainly become a beacon for tourists and locals alike since its construction in 2004. When creating the Agbar Group's new headquarters the architect, **Jean Nouvel**, drew much inspiration from the nearby Montserrat Mountains. But inevitably the people of the city have commandeered the naming of the building as their own, affectionately calling it *el consolador* ("the dildo"), *supositorio* ("suppository"), or simply *la polla* ("the cock").

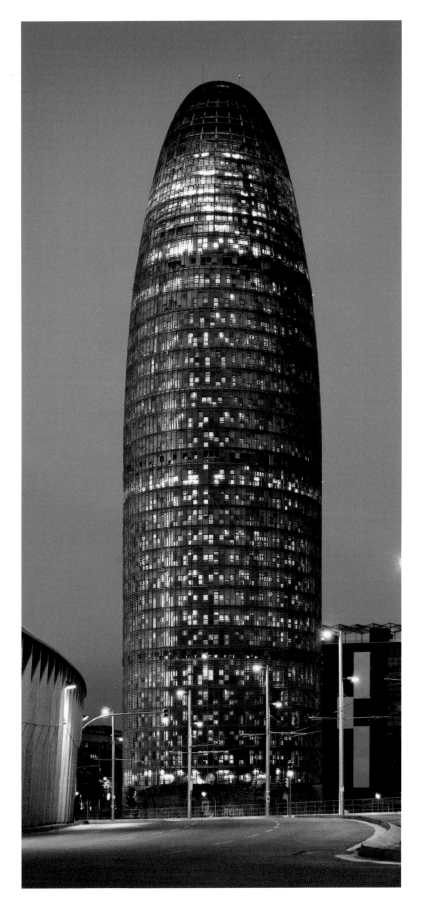

Jean Nouvel. Agbar Tower

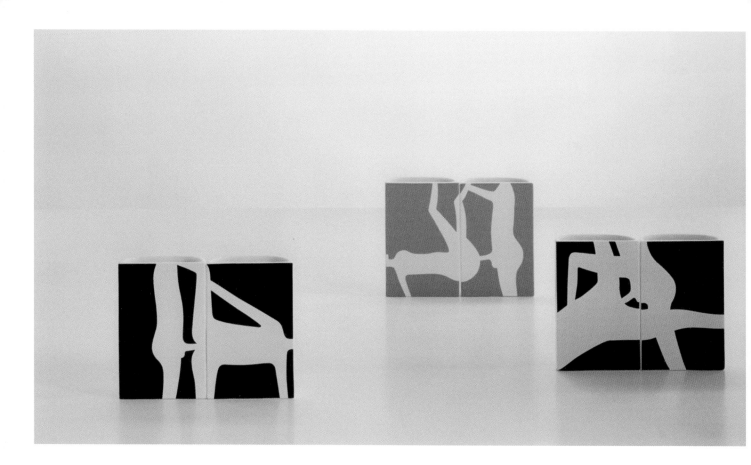

In 2,000 years, when the archaeologists of the future dig up our civilization, what will they think? If they discover the **Ceram X** vases designed by **Pierre Charpin** for **Craft**, they may think things haven't changed much since ancient times. The style of these pieces is more than slightly reminiscent of ancient Greek frescoes and vases, but Charpin has brought them back from the dead with graphic, abstract, and colorful images, depicting the one theme that hasn't—and won't ever be—changed. Some of the illustrations are very clear in their subject, while others are much more abstract. This leaves the interpretation up to the viewer, now or in 2,000 years.

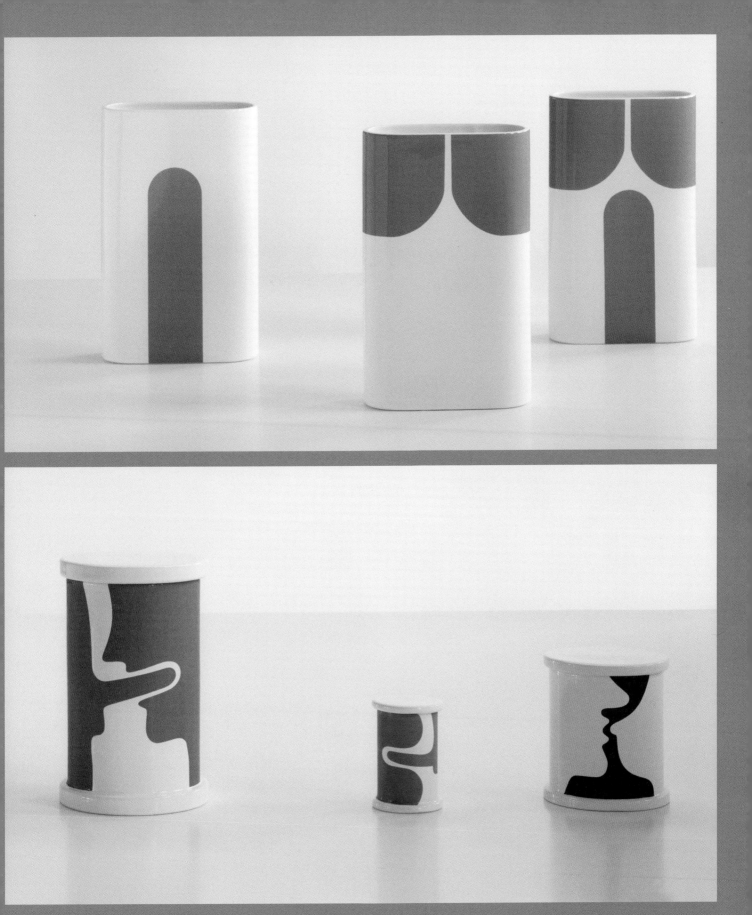

Pierre Charpin. Ceram X for Craft

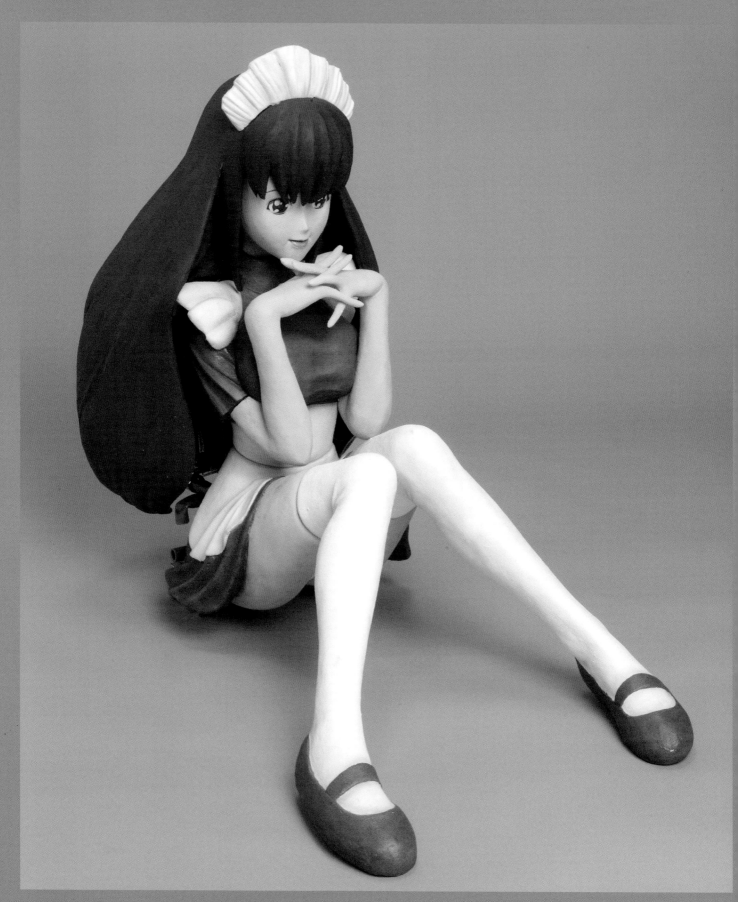

Katsuya Matsumura. Manga Computer Cases

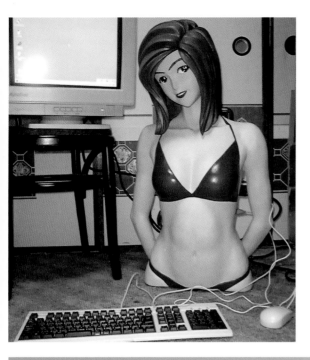

Over the past 30 years computers have become permanent fixtures in our homes and lives. But despite the passion we have for them, their design is all too often boring and gray. With such a significant amount of computer use going to pornography and video games (let's face it, most new technology is used and consumed by young males!), it comes as no surprise that this design void, when finally filled, addressed these trends. Artist **Katsuya Matsumura** has created what every adolescent boy dreams of: handmade computer cases that combine comics, sex, and video games in a bold and meticulously crafted way. The sexual innuendo of sliding a disc into its drive has never been clearer.

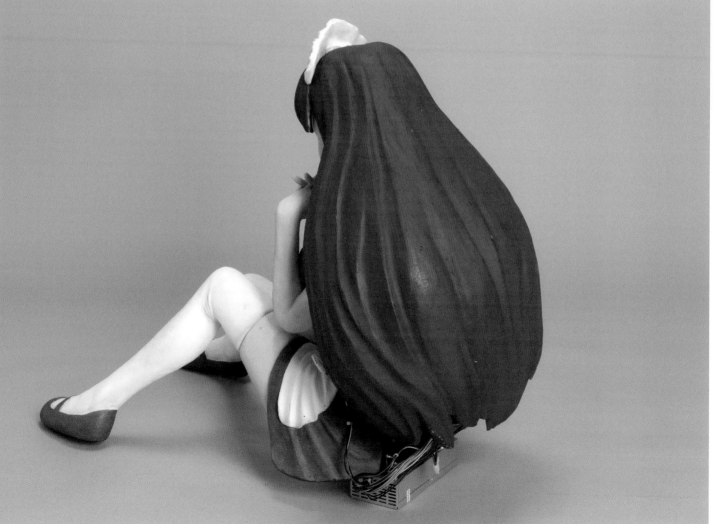

Katsuya Matsumura. Manga Computer Cases

Anthony Kleinepier. Dickies for Moooi

Not many people could make the concept of sitting on someone's balls sound comfortable, but that's exactly what **Anthony Kleinepier** did when he designed his **Dickies** furniture, produced by the Dutch design collective **Moooi**. Working in his signature linear and cubic style, he focused on extreme comfort throughout the entire design process, but never lost track of the subject matter at hand. And just like in real life, the Dickies come in all different shapes, colors, and sizes.

With **Pornogobelin**, media artist **Martin Bricelj** tries to revive an all-but-forgotten bourgeois phenomenon and encourage people to decorate their home with their own art. Porn stars turn into the main stars of tapestries. Pornogobelins fuse the virtuousness of past lives, the tapestries, with the decadence of our time, pornography. The project was presented at a lavish bourgeois home in Ljubljana (it was demolished two months later), with women dressed in the appropriate bourgeois fashion while carrying out the laborious and repetitive work of the tapestry, the largest piece taking up to 1,200 hours of handwork.

Martin Bricelj. Pornogobelins

Martin Bricelj. Pornogobelins

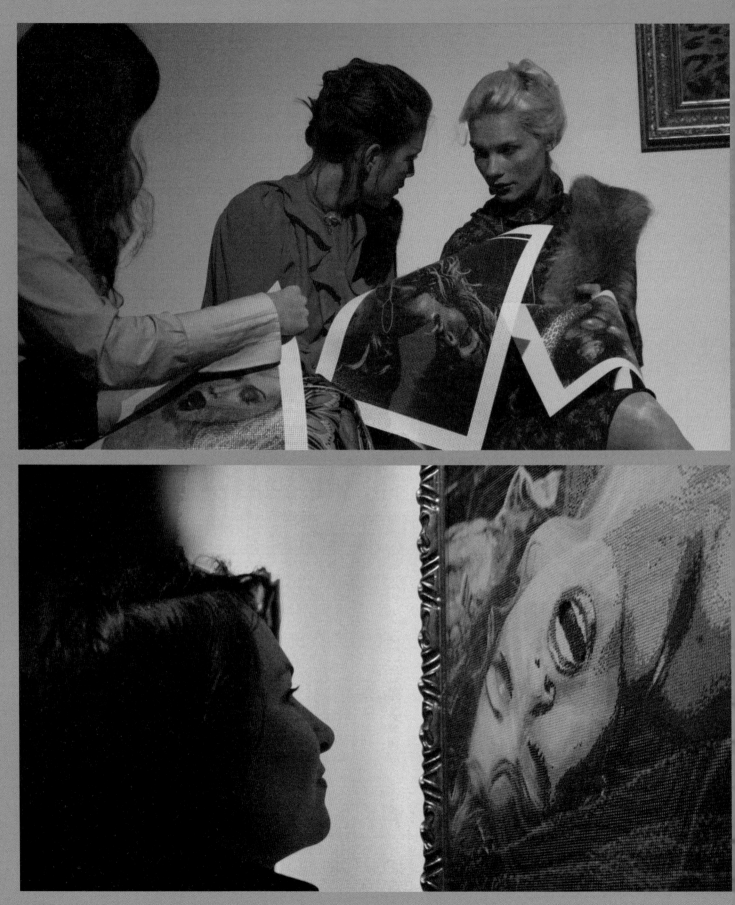

Martin Bricelj. Pornogobelins

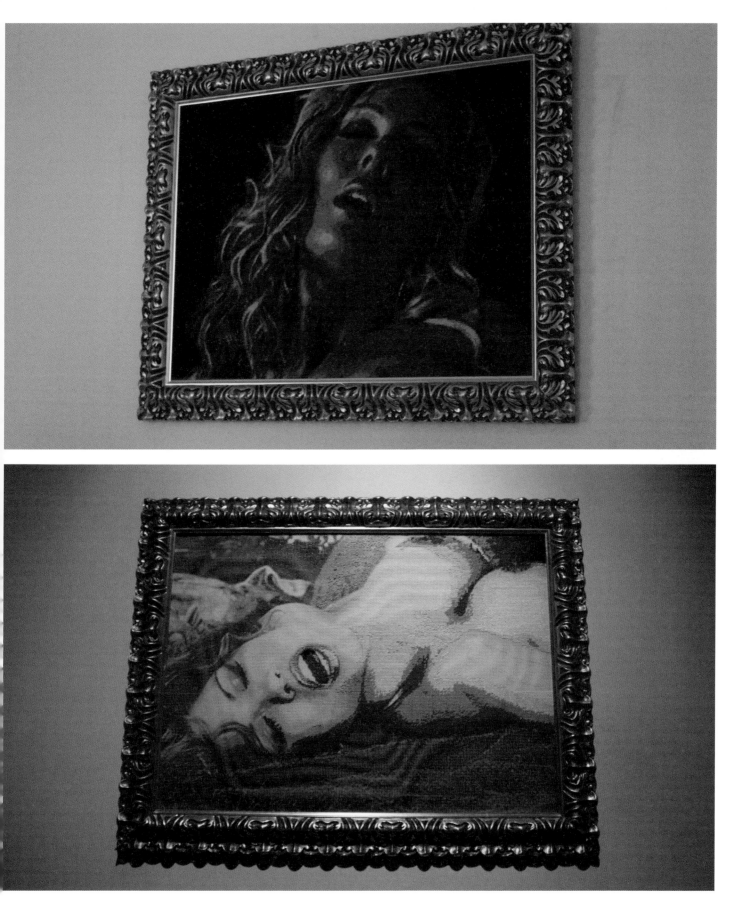

Martin Bricelj. Pornogobelins

128

→ **IT IS ROMANTIC**

As much as our world has opened up to the idea of sexual freedom and has moved away from traditional love stories, true romance is something we can never leave behind. We will never stop courting one another with food, drink, art, music, poetry, gifts, and more. There are also very few things in this world more romantic than a special place for two lovers to enjoy each other's company, whether that space is quiet and familiar or much more gaudy. The objects and places we encounter along this amorous path need to have something special and romantic in their design to keep us interested, turned on, and never alone.

In addition to the idea of courtship, communication is key to all relationships and well-oiled romances. Communication can include everything from your fantasies and fears to what side of the bed you like to sleep on. But we all know there are some times when we feel we're just not speaking the same language as the other person, and sometimes we actually aren't. So when the language of love falls short of saying much more than "I'm horny right now," good design can be relied on to get the message across and let someone know how you feel.

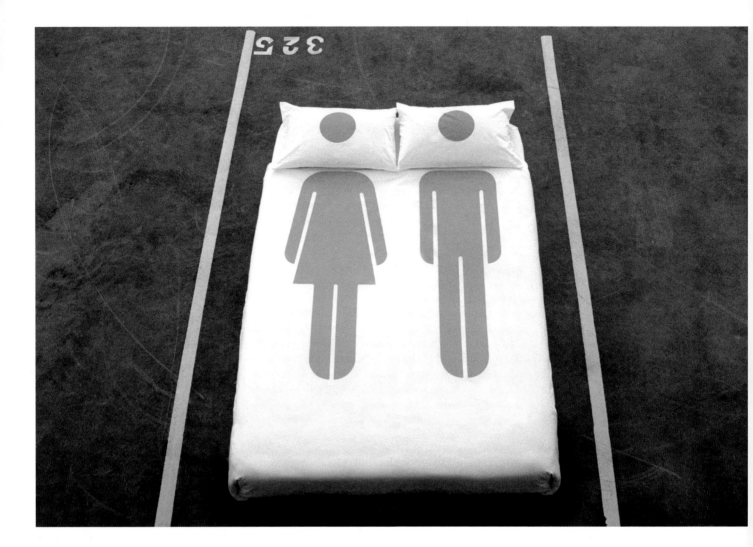

Communication is the most important thing in a relationship and good design always communicates something about who you are and what you enjoy. The Australian designer **Belinda Johnstone** founded **No One You Know Homewear** in 2002 and made her debut with these OtlAicher-inspired sheets. Their clean, classic design lets everyone know a lot about who you are, such as who like to sleep with and on which side of the bed. Communication couldn't be easier! No One You Know is also based on the philosophy that art belongs in our everyday lives, and since every set of sheets is a hand-pulled silk screen, it actually puts art in bed with you. Sleeping with art, sleeping with your lover, and not worrying if your side is going to be taken when you get to bed—is there anything design can't do?

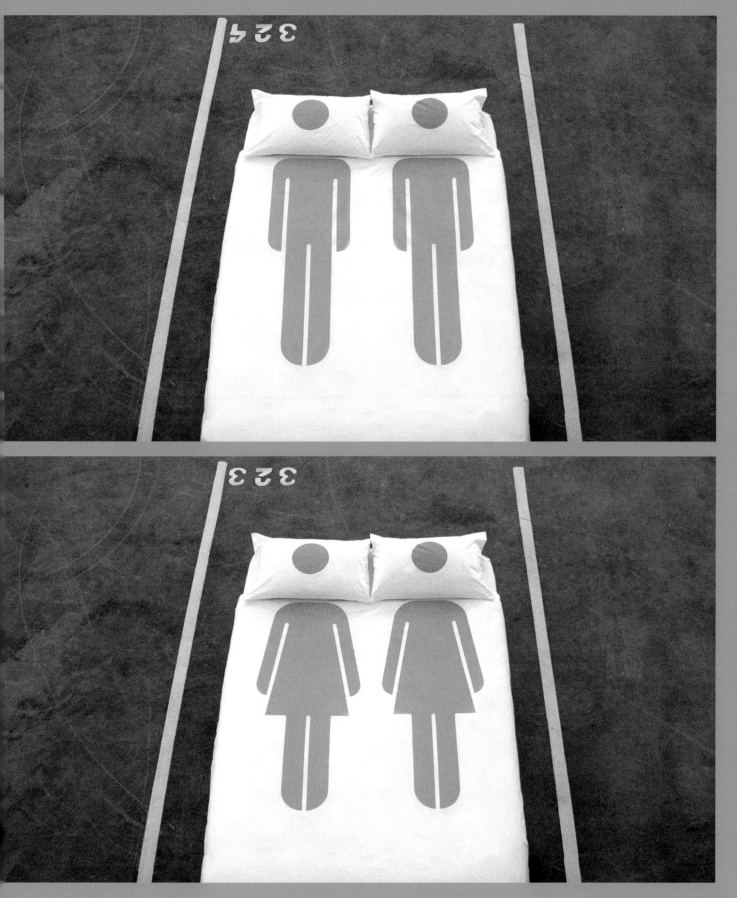

Belinda Johnstone. Bedsheet for No One You Know

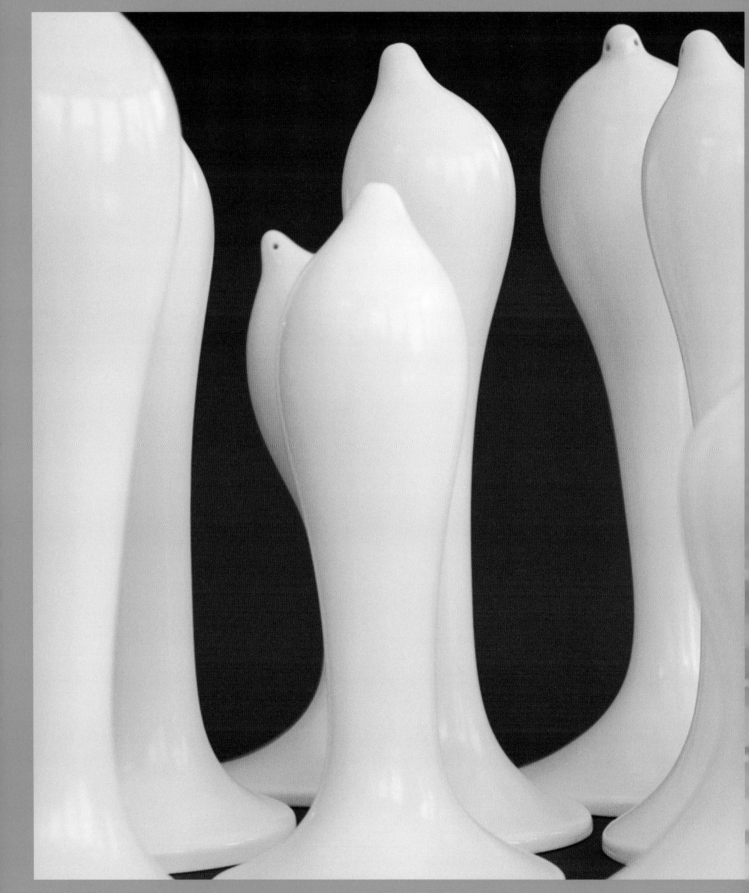

WEmake. The Condoments Salt and Pepper Shakers

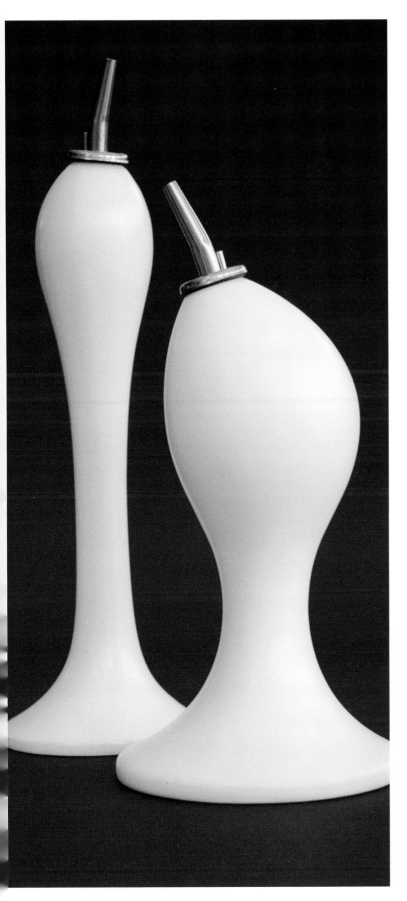

Good food and sex have always been complementary, and a romantic dinner can quickly escalate into an orgasmic banquet. But there are two things we can't forget: if we're going to cook we need salt and if we're going to have sex we need condoms.

The British design team **WEmake** has brought safe sex to the dinner table with its **Condoments** shakers and drizzlers. While we're usually more occupied with getting the condom on than appreciating its design, these dinner table accessories highlight just how sensual that form can be. The pieces are at the same time masculine and feminine, decorative and functional, and above all they promote conversation *and* safe sex. So enjoy your meal, but first, could you pass me a condom? The potatoes need salt.

WEmake. The Condoments Oil and Vinegar Drizzlers

A circle has no beginning and no end, making the ring the perfect symbol of a lasting relationship. Because of this it has long been our way of showing commitment and devotion to someone, and is one of the oldest traditions in Western marriages. Tradition can be a good thing, but breaking tradition and evolving our attitudes, and eventually our laws, is also important. As countries across the world begin to accept same-sex marriages, there have been a few pioneers who have approached the new political and social challenges in ways designed to excite us, incite action, and open minds. For the world-renowned jewelry designer **De Plano Group**, this came in the form of the **Love & Pride** collection, the first high-end collection of commitment rings and wedding bands created especially for gays and lesbians. The designs are dazzling and distinguished, and appeal to the most refined tastes. As our society's ideas about love and romance evolve, we can only hope that the designs that reflect these ideas may help open other people's minds.

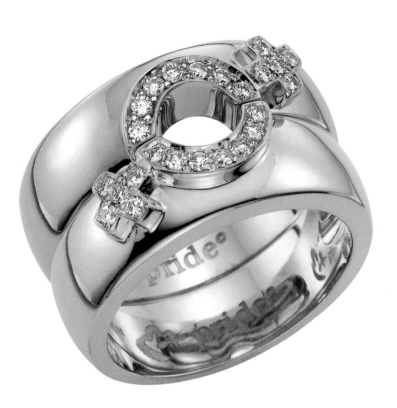

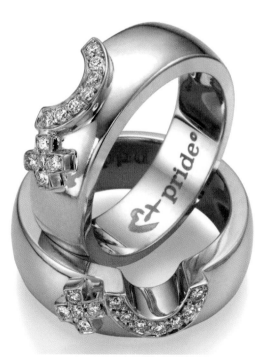

De Plano Group. Same-sex Wedding rings for Love & Pride

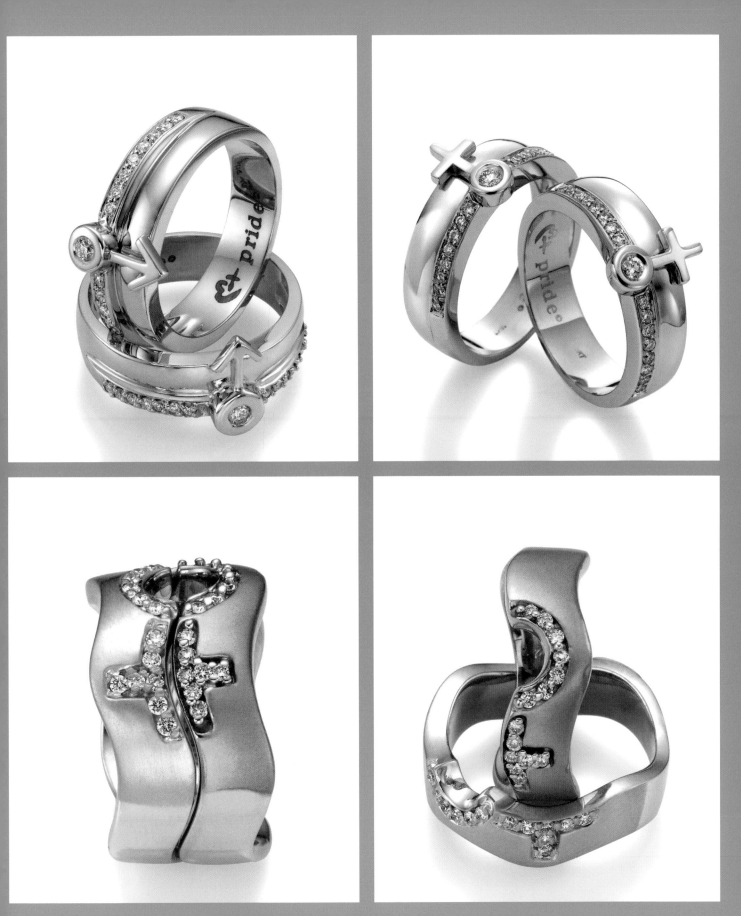

De Plano Group. Same-sex Wedding rings for Love & Pride

Alberto Mantilla. Hug Salt and Pepper for Mint NYC

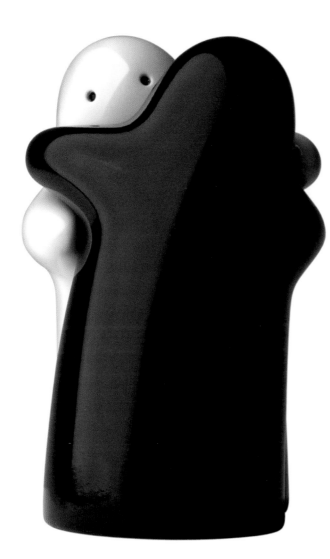

We all feel special when someone is willing to share something with us, from a glass of wine to his or her whole body. However, generally before you are sharing beds, sweaty embraces, and moments of ecstasy you have to share other intimate moments, like a meal. The designers **Alberto Mantilla**, **Scott Henderson**, and **Tony Baxter** came together to form **Mint NYC**, and have found a special place in their hearts for creating designs that are intended to bring two people closer and spark a little romance. When our salt and pepper shakers seem to be just as in love as we are, or when the very plates and cups we are eating and drinking from are specifically designed with two lovers in mind, we are certain to start up some great conversations, and hopefully more.

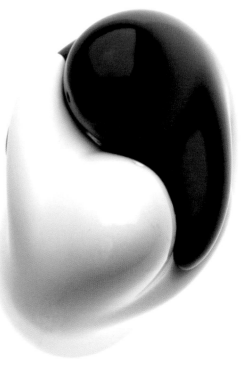

Tony Baxter. Sushi time for Mint NYC

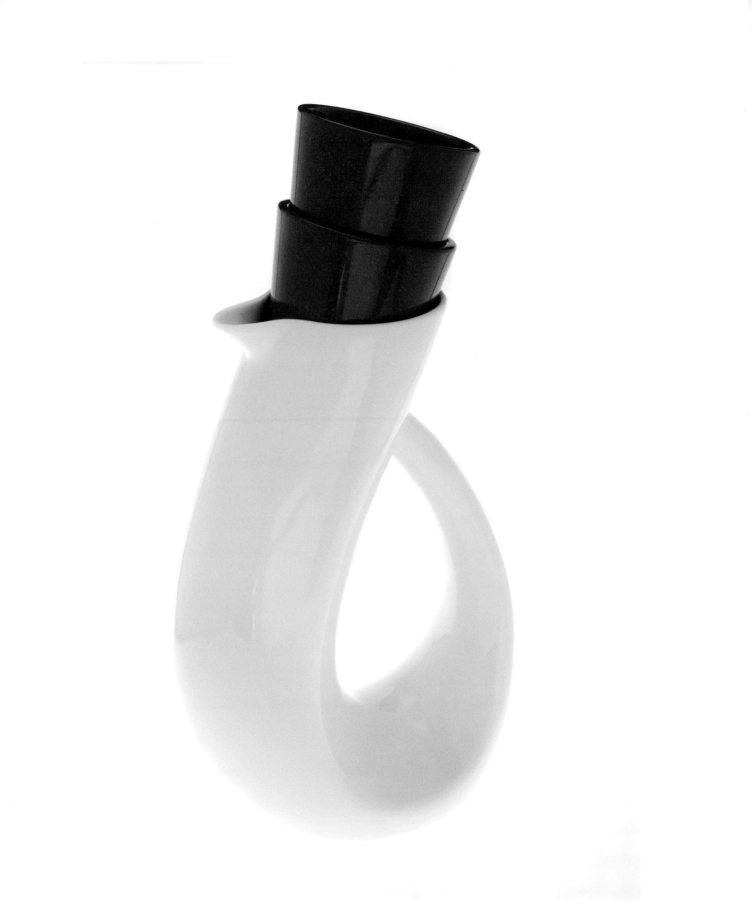

Scott Henderson. Vin/Eau Carafe for Mint NYC

The joining of a couple in matrimony is a romantic and sweet affair for all those present. Having a celebration that is beautiful, unique, and memorable is more often than not a main concern at most weddings, and the world-renowned pastry artist **Ron Ben-Israel** has built his reputation on baking up some of the most outstanding creations for just such occasions. His wedding cakes are some of the most noted in the world and have received praise from theZagat's food guide and even Martha Stewart, as well as many satisfied couples and their guests. Just how romantic a wedding will be is up to the couple getting married, but if they put as much love into their relationship as Ron Ben-Israel does into his cakes, it's sure to be quite an affair.

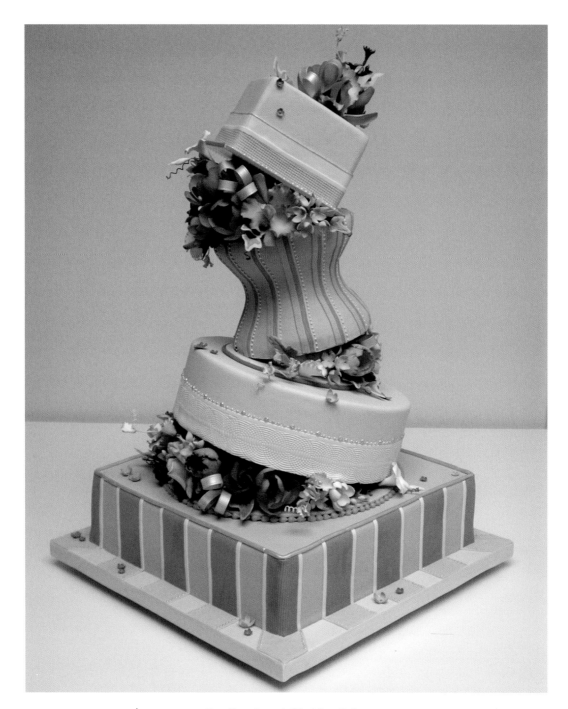

Ron Ben-Israel. Wedding Cake

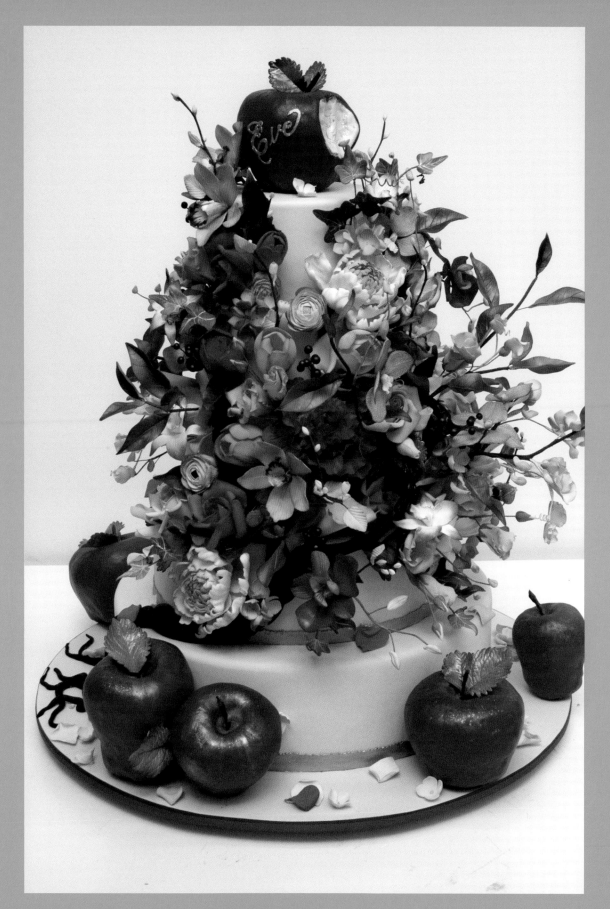

Ron Ben-Israel. Wedding Cake

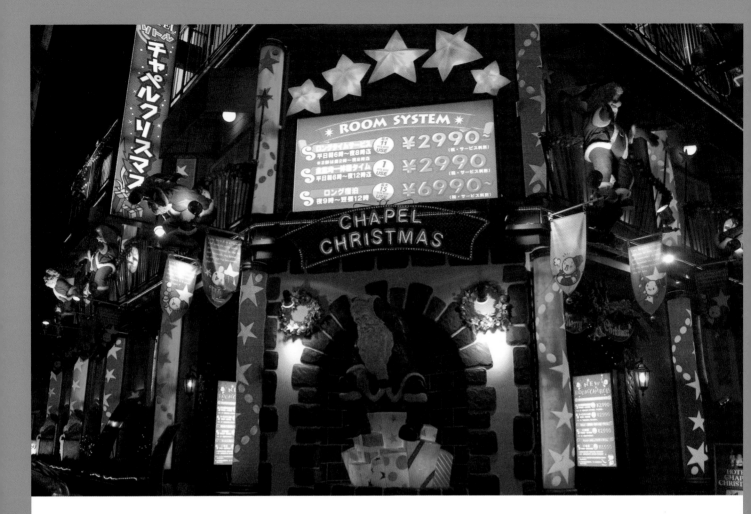

Seeing a flashlight shine through the car window just as you're about to get your pants off is a sure sign you and your lover need a better place to sneak away to. Throughout the world cheap motels are the standard for couples looking for privacy, but most of these pay-by-the-hour spots aren't the most romantic or inviting places, to say the least. But for decades the **Japanese Love Hotels** have taken things to a level that is at times truly out of this world. What once were seedy little places on the outskirts of town have become elaborate fixtures within the big cities. This is mostly thanks to the famous love hotel designer, **Amii Shin**, who during the 1970s helped open people's minds by creating hotels that could be admired and celebrated. Believing that sex should be something playful, he infused all of his designs with bright colors and cute features, appealing to the child in all of us. These hotels are viewed not as kitschy and cheesy, but rather as sexual theme parks where we can escape from our normal lives and live out our fantasies. With this concept in mind, many of these hotels offer a variety of special features. Some may provide S&M gear, special bathtubs (very important, as Japanese culture strongly equates sex with bathing), tanning beds, miniature tennis courts, and even bumper cars and theme rooms. The love hotels are proof that even though we all inevitably grow up, we can still have as much fun as when we were kids—maybe even more.

Japanese Love Hotels. Photos by Ed Jacobs

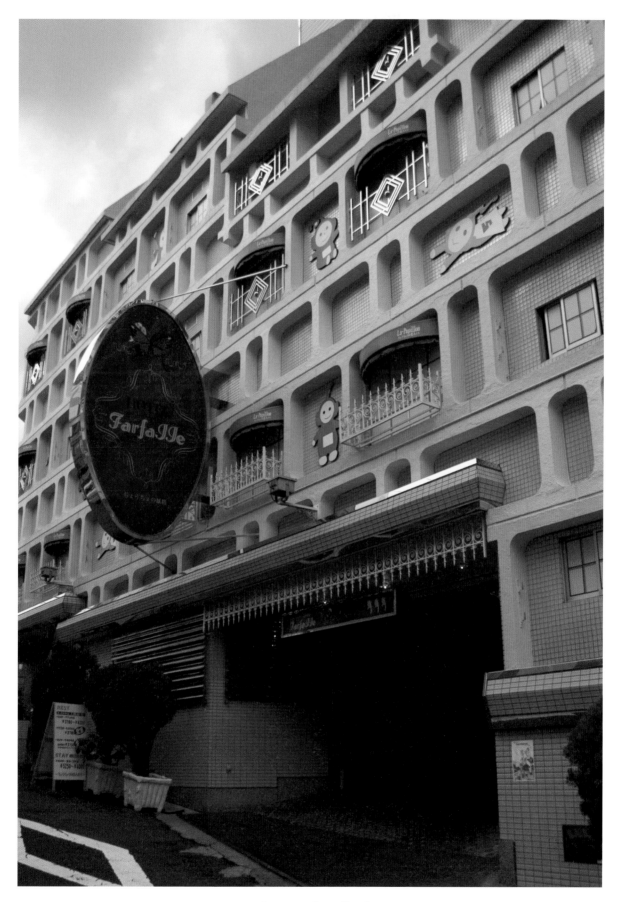

Japanese Love Hotels

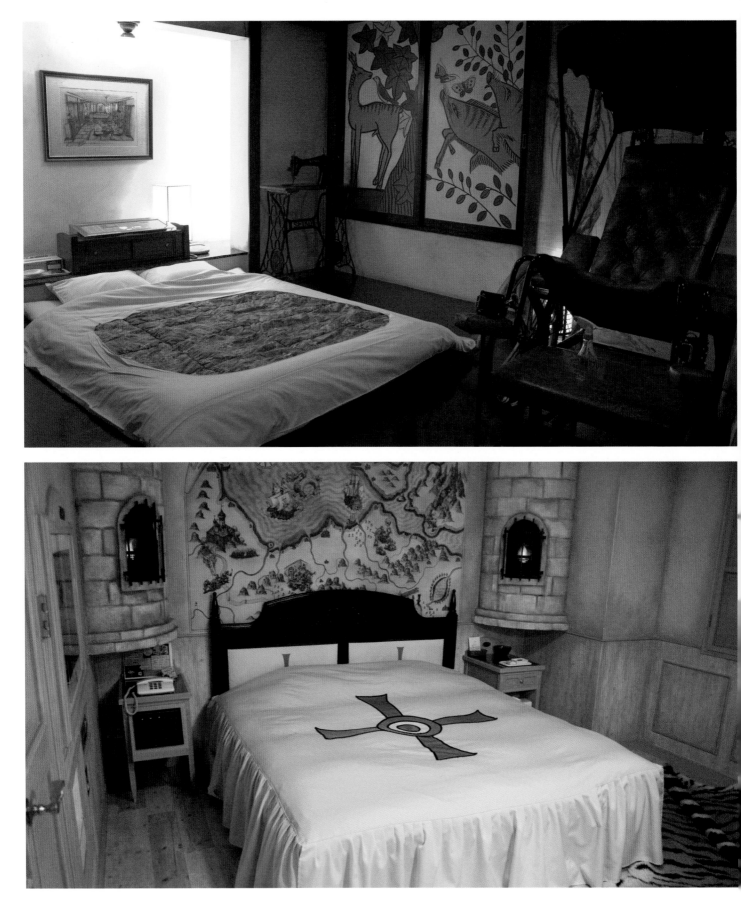

Japanese Love Hotels

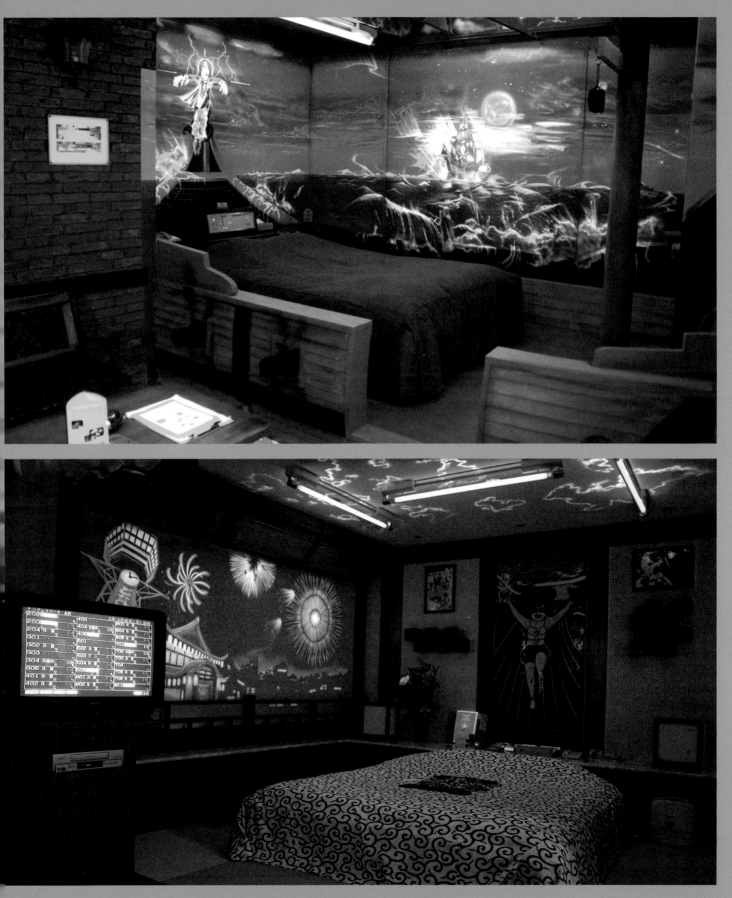

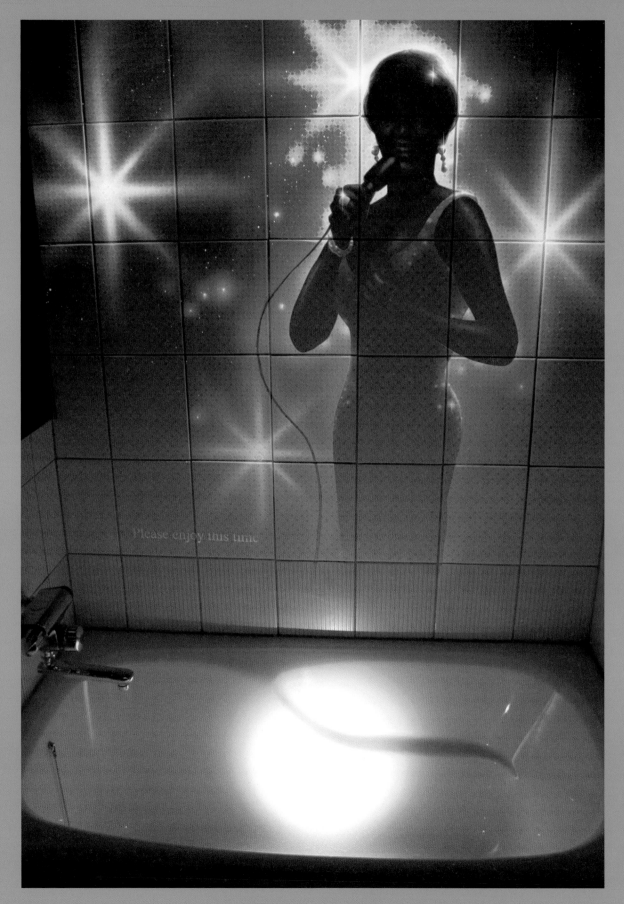

Japanese Love Hotels

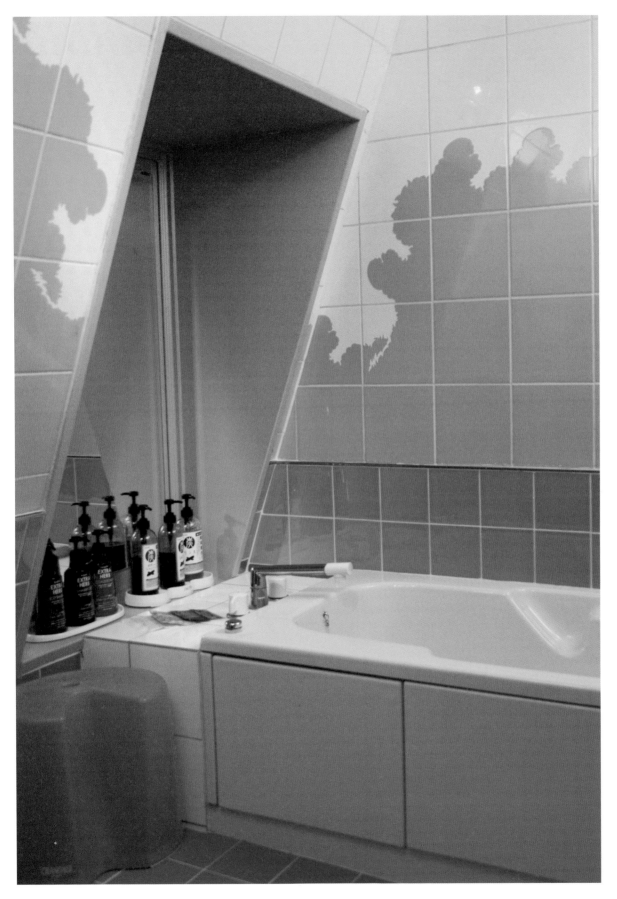

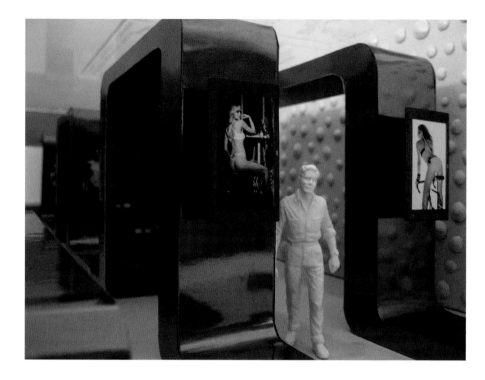

Buying gifts is romantic, but it is rarely an easy task. For men, buying bras for their significant other can be an enormous challenge. When asked by a salesperson, "So, what size bra does she wear?" they are often reduced to staring at other women in the store or hopelessly mimicking with their hands. This prompted the designer **Wendy Rameckers** to come up with a lingerie store concept created specifically for men. The hundreds of silicone breasts covering the wall allow men to touch and stare all they want in order to choose the right bra size. And even if this sounds a little too much like a horny guy's amusement park, you can be sure that it also means the girlfriends will get more lingerie.

Wendy Rameckers. Lingerie Store Concept

150

→ IT KNOWS NO LIMITS

Humans are naturally curious and mischievous little creatures. It just seems to be in our nature to want to explore everything and everybody around us, as well as ourselves. We have always insisted on pushing the limits, from our technology to great feats of strength or endurance, but above all we are constantly searching for new pleasures. So why is it that we seem to be so quick to pass judgment on one another for trying something new or doing something differently?

Even in today's increasingly liberal world there are many sexual taboos relating to whom we choose to have sex with, how we choose to do it, how old we should be, how many people we should or should not do it with, where we decide to do it, what parts of our bodies we use while doing it, and even talking about doing it is considered wrong in some places. Some of these have risen out of what people deem is "safe" behavior, for yourself and those around you, while others come more from what is "appropriate" for "normal" men and women to engage in. How then do mentalities change?

Even some of the most difficult and taboo sexual topics can be presented as glamorous and enticing, cute and humorous, or even traditional and nonthreatening. The way it is all presented to us is the key factor. Design has power and can make even the scariest topics seem like a lot of fun.

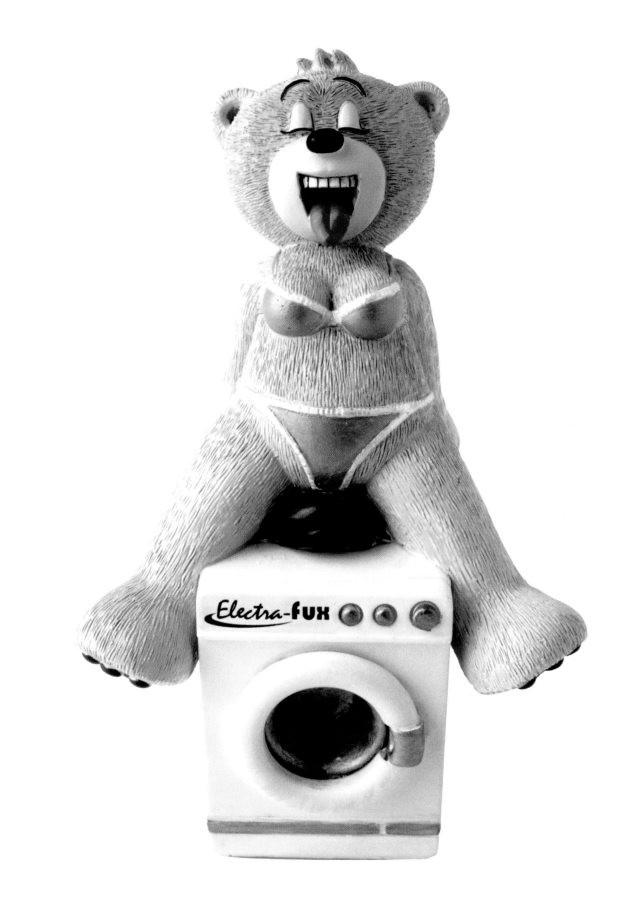

Pete Underhill. Bad Taste Bears (Electra) for Piranha Studios

Pete Underhill, creator of the **Bad Taste Bears**, was doing cutesy illustrations for a pajama company in England when he came up with the idea for his collection of twisted and taboo bears. They grew out of a knee-jerk reaction he had one night in 1994 while he was pumping out his tame creations. These bears were just dying to break out of their pajama prison and let their sexual and destructive urges run wild. The religious bears just wanted to get some action, and lonely bears turned to their household appliances for some pleasure. The taboos were pushed in utter bad taste, and these toys/sculptures quickly gained international popularity and even have their own global collectors' community. So don't forget, appearances may be deceiving: even the most seemingly innocent creatures have their dark side.

Pete Underhill. Bad Taste Bears (Theresa) for Piranha Studios

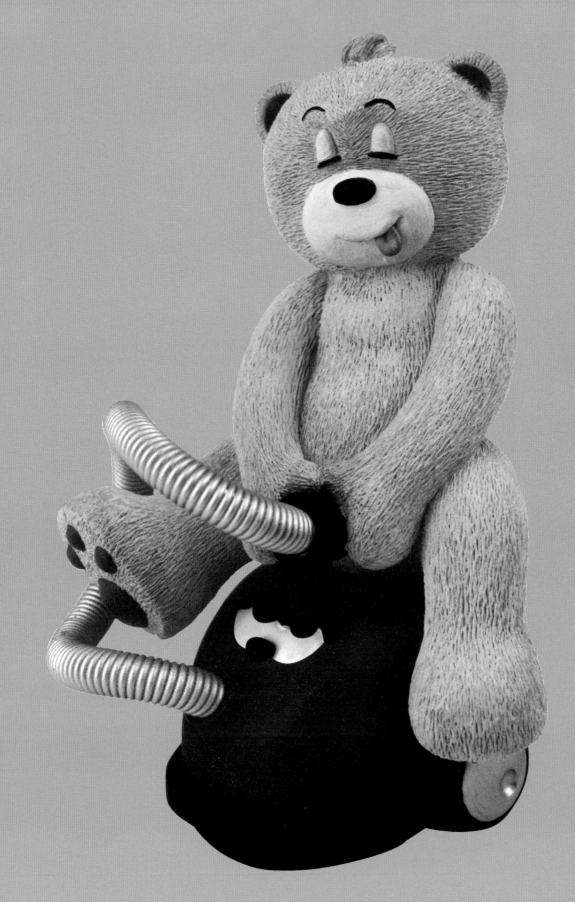

Pete Underhill. Bad Taste Bears (J. Edgar) for Piranha Studios

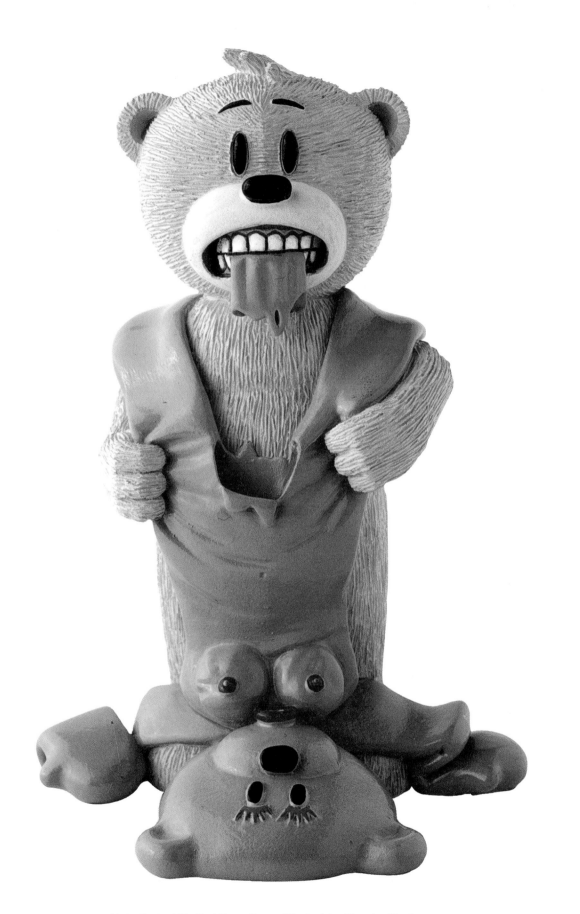

Pete Underhill. Bad Taste Bears (Buster) for Piranha Studios

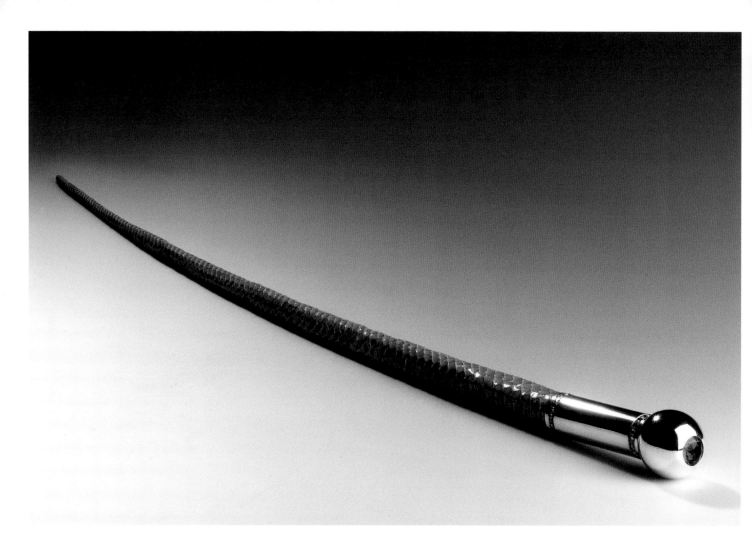

What does pain add to pleasure? Well, there is actually a scientific reason: the release of endorphins into your system from the experience of pain. The endorphin rush gives you a high, similar to opiates, so when you combine that with the pleasure of sex it might get you going like you never thought possible. Still not convinced, huh? Even if that doesn't tempt you, **Shiri Zinn**'s exquisite tools of sexual discipline just might. Pulling out a wooden paddle while having sex might seem a bit crude, but when a turquoise snakeskin whip, with a diamond-encrusted handle and a blue zircon set stone, comes out of the closet, it might be a little harder to say no.

Shiri Zinn. Whips

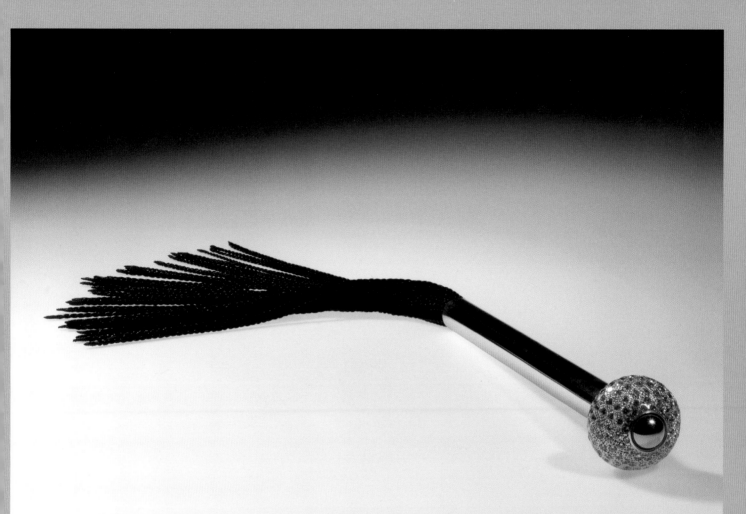

The materials used for these pieces have rarely been seen in such erotic creations, but their artistry, glamour, and decadence may just get you to push yourself a bit more than you normally would.

Shiri Zinn. Flail

The female form is in its essence curvaceous, sensual, elegant, and graceful. For **Manuel Albarran** the only thing necessary for bringing out the beauty in all of us is to accentuate our natural curves and embellish on them. He often highlights what we were born with by mixing in unnatural elements. These are often either futuristic and quote the world of science fiction, or they show how it we have altered our bodies in the past, specifically through the use of corsetry. Drawing much inspiration from the world of classic fetish as well as futuristic styles, his elaborate and beautiful corsets and unique and shocking metal sculptures are all intended to combine the disparate worlds of the natural and the unnatural, and push them both to new limits.

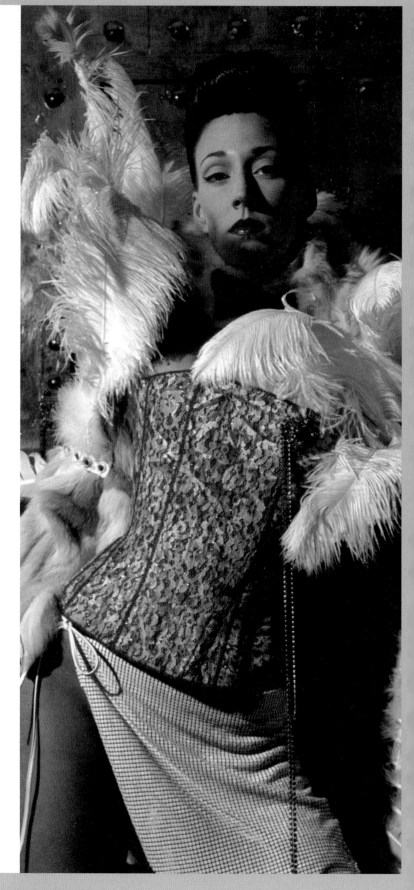

Manuel Albarran. Corset

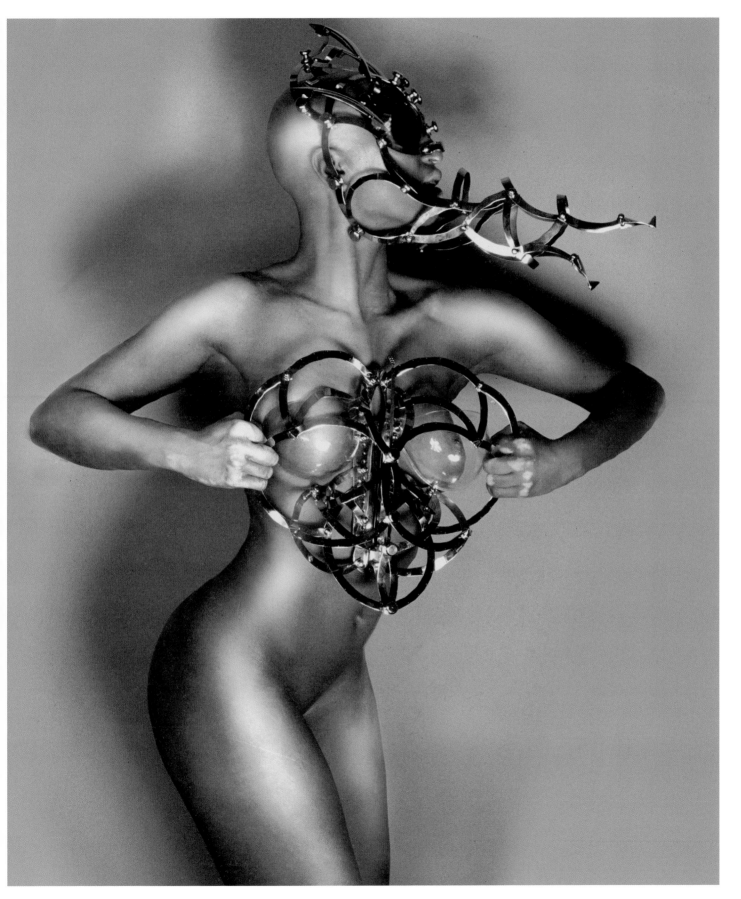

Manuel Albarran. Metal Sculpture and Masc

How often have we ended up on a sofa or sprawled across a counter in the throes of passion? It is obvious that furniture can often offer us much more than a place to sit or rest our things, but these other alternatives are often chosen more because more because of the piece's location rather than its actual design. Why get up and move to the bedroom when you've already started things on the couch? What do you do when a game of strip poker starts to really get interesting? Can the table take that kind of abuse?

Mark Brazier-Jones designed his **Flashman Collection** with the idea of pushing the limits of what we can do in our bedrooms, as well as throughout the rest of our house, yet in the most discreet and stylish way. The beautifully crafted pieces use beaten leather and metal accents, which provide the perfect camouflage of antique furniture while at the same time strongly referencing their possible use as bondage, S&M, fetish, or just straight sexual furniture. Each piece is absolutely intended to be fully functional and ready for riding, swinging, bouncing, strapping down, tying up, whipping, spanking, and just about anything else you can come up with. They leave the curiously tempting option open of hosting a nice quiet dinner party and then turning your home into something out of *Eyes Wide Shut*. However, if you choose to keep the pieces secret nobody will be the wiser, and they may even be impressed by your refined and classical tastes.

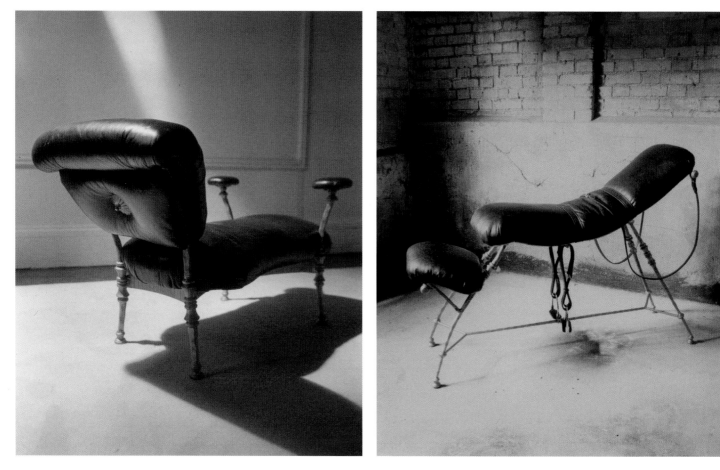

Mark Brazier-Jones. Flashman Collection

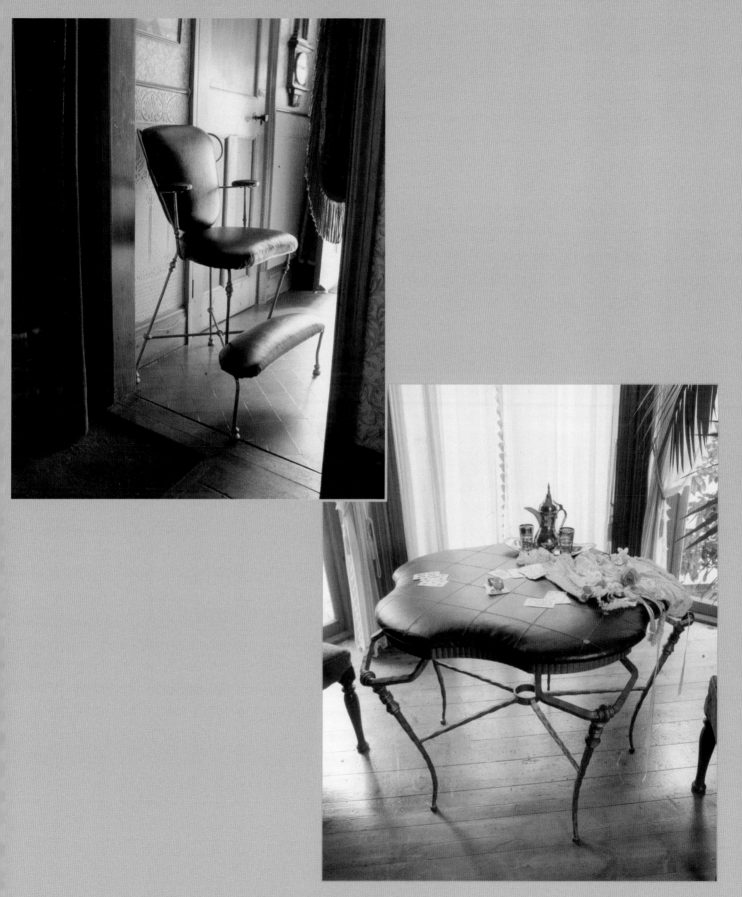

Mark Brazier-Jones. Flashman Collection

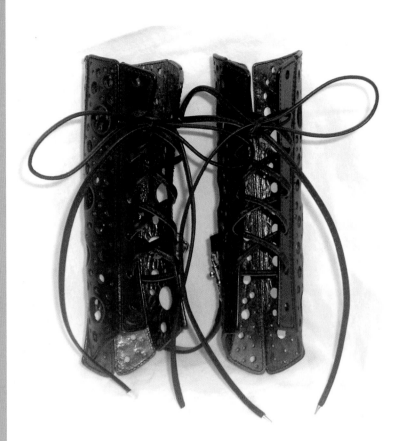

Leather has a raw animal quality that makes some people feel tough and sexy, while others see its use as cruel and callous. These reactions to leather, as well as its strength and unrefined aesthetic, seem to have made it one of the most popular materials for bondage clothing and accessories, although bondage itself is often considered outside the norm and taboo. But the fact is that the majority of leather vests, chaps, straps, and accessories have about as much sex appeal and style as a belt sander, despite the fact that they are intended for such intimate activities. This is why the British erotic boutique **Coco de Mer** has collaborated with artists to put together a collection of restraints and leather goods that have as much of a sense of fashion as they do pure eroticism and function. In fact the designer of the leather gauntlets, **Paul Seville**, has created various pieces seen in runway shows of fashion giants such as Alexander McQueen, Vivienne Westwood, and Victoria's Secret. Regardless, both of these designers, **Hoi Chi Ng** and **Paul Seville**, have produced dazzling restraint devices that are intended for the utmost refinement and taste as well as plenty of naughtiness.

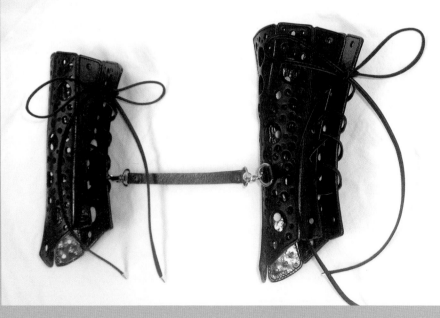

Paul Seville. Gauntlets for Coco de Mer

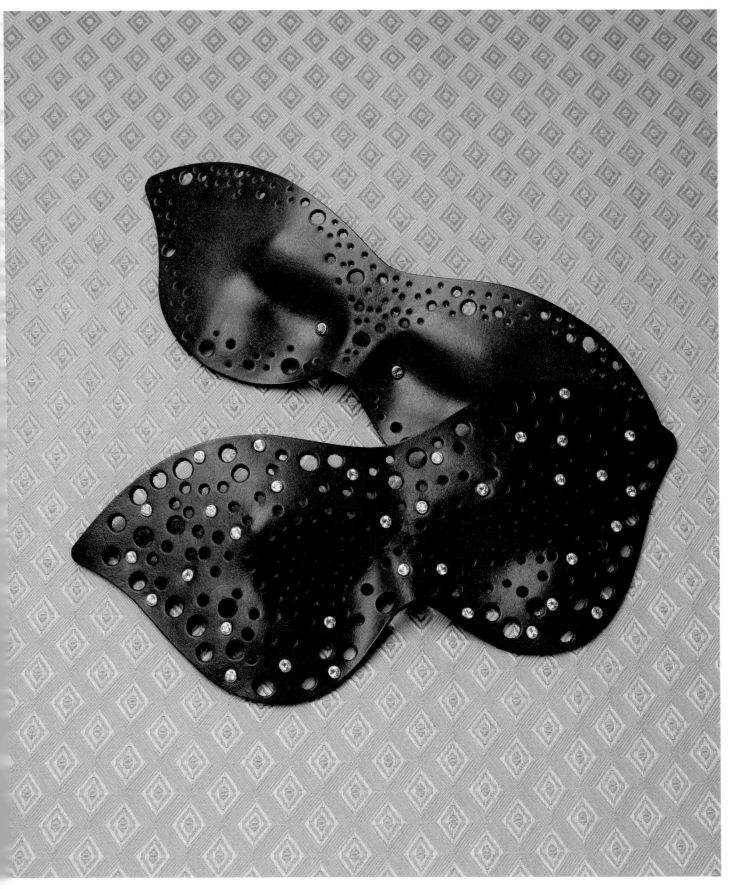

Hoi Chi Ng. Leather Blindfold for Coco de Mer

Act-Up Paris
BP 287
75525 Paris
France
t +33 01 48 06 13 89
f +33 01 48 06 16 74
www.actupparis.org

Adriana Bertini
Dr. Amâncio de Carvalho, 110/06
Vila Mariana -Sâo Paulo - SP
Brazil
t +55 11 3151 27 59
www.adrianabertini.com.br

Anthony Kleinepier
ubik@xs4all.nl
www.anthonykleinepier.nl

Big Teaze Toys
22250 Miston Dr.
Woodland Hills, CA 91364
USA
t +1 818 716 61 49
f +1 818 884 39 98
www.bigteazetoys.com

Blobb
387 14th St. 1
Brooklyn, NY 11215
USA
t +1 347 613 80 78
www.blobb.us

Brothersister
Holland House, 42 St. Georges Road
Broadstairs Kent, CT10 1NR
UK
t +44 0 184 360 0561
f +44 0 184 360 0561
www.brothersister.co.uk

Bruce Gray
688 South Ave. 21
Los Angeles, CA 90031
USA
t +1 323 223 40 59
www.brucegray.com

Carlos Mollino
mollino@designboom.com

Cinzia Ruggeri
Corso Buenos Sires 2
Milan 20124
Italy
t +39 0 2 295 133 10

Coco de Mer
t +1 866 959 26 26 (USA)
 +44 0 207 836 8882 (UK)
www.cocodemer.com

Craft
Impasse Becquerel
87000F Limoges
France
t +33 05 55 49 17 17
f +33 05 55 05 11 15
www.craft-limoges.org

Cum
contact_cum@hotmail.com

Cute Circuit
30 Fashion St.
London E1 6PX
UK
t +44 0 776 544 5002
www.cutecircuit.com

De Plano Group
95 Madison Ave.
Penthouse Floor
New York, NY 10016
USA
t +1 212 213 2224
f +1 212 889 8337
www.deplano.com

Divine Intervention
divine-intervention.com

Erotic Museum L.A.
6741 Hollywood Blvd.
Hollywood, CA 90028
USA
t +1 323 463 76 84
f +1 323 463 76 50
www.theeroticmuseum.com

Estudio Merino
Joaquín Costa, 47, Bajos, Local 2
08001 Barcelona
Spain
t +34 93 301 65 10
www.estudiomerino.com

Ingo Maurer
www.ingo-maurer.com

Intimsport
Glogauerstr. 6
10999 Berlin-Kreuzberg
t +49 0 30 301 300 15
Germany
www.intimsport.com

Jean Nouvel
10 Cité d'Angoulême
75011 Paris
France
t +33 1 49 23 83 83
f +33 1 43 14 81 10
www.jeannouvel.fr

J-Me
Unit 27 f2, n17 Studios
784-788 High Rd.
London n17 0da
UK
t +44 0 208 365 1136
f +44 0 208 365 1236
www.j-me.co.uk

Joe Capobianco
817 Chapel St. Suite 2F
New Haven
06510 Connecticut
USA
t +1 203 752 05 64
f +1 203 752 05 66
www.hopegallerytattoo.com

Julian Murphy
julianmurphyart@hotmail.com

Junko Mizuno
489 Fair Oaks St. 6
San Francisco, CA 94110
USA
t +1 415 642 59 35
www.japress.com

Karim Rashid
137 W 19th St.
New York, NY 10011
USA
t +1 212 337 80 78
f +1 212 337 85 15
www.karimrashid.com

Katsuya Matsumura
www.011.upp.so-ne.jp/kat/

La Fille d'O
Holstraat 91
9000 Gent
Belgium
t +32 486 68 85 10
www.lafilledo.com

Manuel Albarran
transparents@hotmail.com

Mariana Chiesa
Ample, 28
08002 Barcelona
Spain
t +34 657 065 220

Mario Philippona
sexyfurniture@sexyfurniture.nl

Mari-Ruth Oda
9 Marriot St.
Withington Manchester
M20 4BN
UK
t +44 0 161 429 7778
www.mari-ruthoda.com

Mark Brazier-Jones
Hyde Hall Barn
Buckland, Buntingford
Hertfordshire SG9 0RU
UK
t +44 0 1763 273 599
f +44 0 1763 273 410
www.brazier-jones.com

Martin Bricelj
www.codeep.org

Mia & Jem
www.miaandjem.com

Mike Giant
www.mikegiant.com

Mint NYC
601 W 26th St. 18th Floor, Suite 1820 A
New York, NY 10001
USA
t +1 212 352 02 38
f +1 212 352 01 69
www.mintnyc.com

Miquel García
Rocafort, 87 4º 2ª
08015 Barcelona
Spain
t +34 630 188 057
miquelnou@yahoo.com

Montse Palacios
San Josep, 53
08760 Martorell, Barcelona
Spain
t +34 93 774 21 18
amorautista@hotmail.com

Myla
77 Lonsdale Rd.
London W11 2DF
USA
t +44 0 8707 455 003
f +44 0 8707 455 004
www.myla.com

Nicolas Estrada
Magalhäes, 5 1º1ª
08004 Barcelona
Spain
t +34 646 218 904
www.amarillojoyas.com

No One You Know
PO BOX 7356
Bondi Beach, NZW 2026
Australia
t +61 2 9365 3321, 0405 666 457
www.nooneyouknow.com

Papabubble
Ample, 28
08002 Barcelona
Spain
www.papabubble.com

Pat Says Now
Weidkamp 180
D-45356 Essen
Germany
t +49 0 20 186 192 06
f +49 0 20 186 194 44

Philip Foeckler
www.option-shift-home.com

Pierre Charpin
40 Rue Marat
94200 Ivry-sur-Seine
France
t +33 01 46 58 22 72
Charpin.pierre@free.fr

Piranha Studios
Benfield Business Park
Benfield Rd.
Newcastle upon Ttne NE6 4NQ
UK
t +44 191 224 4461
www.piranhastudios.com

QuickHoney
536 Sixth Avenue, 2nd&3rd Floor
New York, NY 10011
USA
t +1 646 270 55 62
 +1 646 270 55 92
www.quickhoney.com

Rapsel
t +41 612 81 61 41
schwarz.pr@bluewin.ch

R. Crumb
Lora Fountain-Book Agent
lora@fountlit.com

Ron Ben-Israel
42 Greene St. (Top Floor/Rear)
New York, NY 10013
USA
t +1 212 625 3369
www.weddingcakes.com

Scabetti
40 Westwood Rd.
Leek, Staffordshire ST 13 8DH
UK
t +44 0 153 837 1471
www.scabetti.co.uk

Scott Henderson
www.scotthendersoninc.com

Shiri Zinn
www.shirizinn.com

Smut Clothing
www.mysmut.eu.com

Suck UK
31 Regent Studios
8 Andrews Rd.
London E8 4QN
UK
t +44 0 207 923 0011
f +44 0 207 923 0099
www.suck.uk

Swedish Blonde
www.swedishblonde.com

VTC Vinnie's Tampon Case
78 Fifth Ave. 5th Floor
NY, NY 10011
USA
t +1 212 691 69 55
www.tamponcase.com

WEmake
1 Summit Way
Crystal Palace
London SE19 2PU
UK
t +44 7 962 10 87 82
 +44 7 962 13 87 13
www.wemake.co.uk

Wendy Rameckers
www.rameckers.nu

William Pordy
wpordy@nyc.rr.com